For ERB III

Lydia Panas

THE MARK OF ABEL

KEHRER

FOREWORD

I spent hours looking at photography books when I was growing up. There was one in particular, *The Family of Woman*, which I can still see, page by page, from memory. It seemed to offer information about what the world was like, in valuably specific ways—about what people were like and how they lived their lives.

I also had my father's photographs around to explain things about my own family. When my parents were getting divorced, there was a picture on my wall of my newly married mother in an Edenic glade in Hawaii. She's impossibly young in the picture, in shorts, walking with her arm around the skinny shoulders of her shirtless teenage brother in blue jeans. I knew my uncle as a handsome and troubled adult, but in the picture he's just a boy, and the expression on his face is of pure sweetness with no presentiment of the difficulties that lie ahead. It seemed like a picture of all the things that had been lost: childhood, youth, a marriage, an intact family, first love.

Lydia Panas's work in this book, set against sun-dappled and shadowy greenery, also has an Edenic cast and made me think of the end of Milton's *Paradise Lost*, which was the epigraph for my first novel:

> *The world was all before them, where to choose*
> *Their place of rest, and Providence their guide:*
> *They hand in hand with wandering steps and slow*
> *Through Eden took their solitary way.*

Milton ends with the question of what you do when you've lost innocence and how you move forward. It's an important question for Panas, too: her photographs are set after the fall. Her subjects are people with knowledge, aware of complication and disaster. Even the very young couple standing in a stream

holding hands, the girl in white, turn slightly away from each other, as if uncertain and divided about which way to go.

The transition out of childhood—which brings both knowledge and loss—is the subject of a central photograph in the book. Two young boys and three teenage girls stand in front of the camera. The boys on the left are forthright, the youngest with a questioning look, the older considering the camera with crossed arms. The older girls on the right, in tank tops, have learned to pose like women: the one in the background cocks a hip, the other hugs one arm, her long hair falling across her eye. But the girl at the center is the focus. She wears long basketball shorts, like the boys do, with white stripes down the sides and a bra-like bikini top that's too big. Her hair is shaggy, just longer than the boys', and, like them, she has the unself-conscious round belly of skinny childhood. Soon, the photograph seems to suggest, she'll have the visible hip bones and curves of the older girls, along with their new kind of physical awareness, but right now she is neither one thing nor the other, neither child nor adult, but something unique and fleeting and marvelous as she turns to catch the camera catching her.

In another photograph, a young woman stands with her hand on the shoulder of an older woman who stands below her. The girl wears a purple velvet bodice with open lacing over pale, bare skin and has piercings all the way up both ears. She seems vulnerable—that exposed belly button—but also grounded and reassuring as she regards the camera. She seems to be the adult in the picture, a calming presence blessing the older woman, whose expression has something wild and uncertain in it.

Or consider Panas's teenage son, looking down at his speckled left arm. What might be a splattering of mud or an outbreak of freckles turns out to be a series of elaborate drawings in pen. The boy both displays and protects the decorated arm, and the sunlight creates a balancing effect: a dappling of bright light, rather than dark ink, blends the top of his head into the brush and the trees behind him. He's only part of this world; his mind is partly on his marked skin (*hours*' worth of markings) and partly somewhere else. It's a portrait of teenage boyhood, at once intensely particular and universal.

In another, a girl in the plaid skirt and white blouse of a parochial school uniform stands sideways to the camera beside her mother, whose weary face suggests that she's finished having children but whose hand rests on her five-months-pregnant belly. The girl is nearly an adult, and her mother is having a new baby. It's possible that their faces have expressed joy about that fact at some point, but looking at the photograph it's hard to imagine. The baby seems a burden already and a visible presence between them. I found myself hoping the child could find a happy place in an achingly difficult world.

The circumstances of birth also haunt the photograph of two young women standing together, who seem to be about the same age: one is dark skinned and dark eyed, one blue eyed and pale, but they have the same nose, the same mouth, the same chin. Behind them stands an older blond woman who seems to be the source of those features, although hers are softened by age. The blue-eyed girl seems almost defiant, standing with her sister, half blocking her mother from view. The dark-skinned girl's expression might be a delicate mixture of boredom and annoyance. And does the mother's face reveal some impatience with being stuck back there? The picture answers some questions and raises a torrent of others.

And that's what all of these photographs do. Lydia Panas is fearless in confronting human subjects and frankly curious about human interaction, but her interest is tender. Hidden under the hood of her field camera, she gives her models space to reveal themselves and their connections to each other, and they do—in all their complex glory.

In examining the families we're born into, the ones we create for ourselves, and the mix of the two, Panas offers what I was urgently looking for as a kid poring over photography books. She offers information about the world—about lives as they are lived—and evidence of how that living is done.

Maile Meloy

The exploration of who we are and what we want to become. Is there ever any other subject?

Miuccia Prada

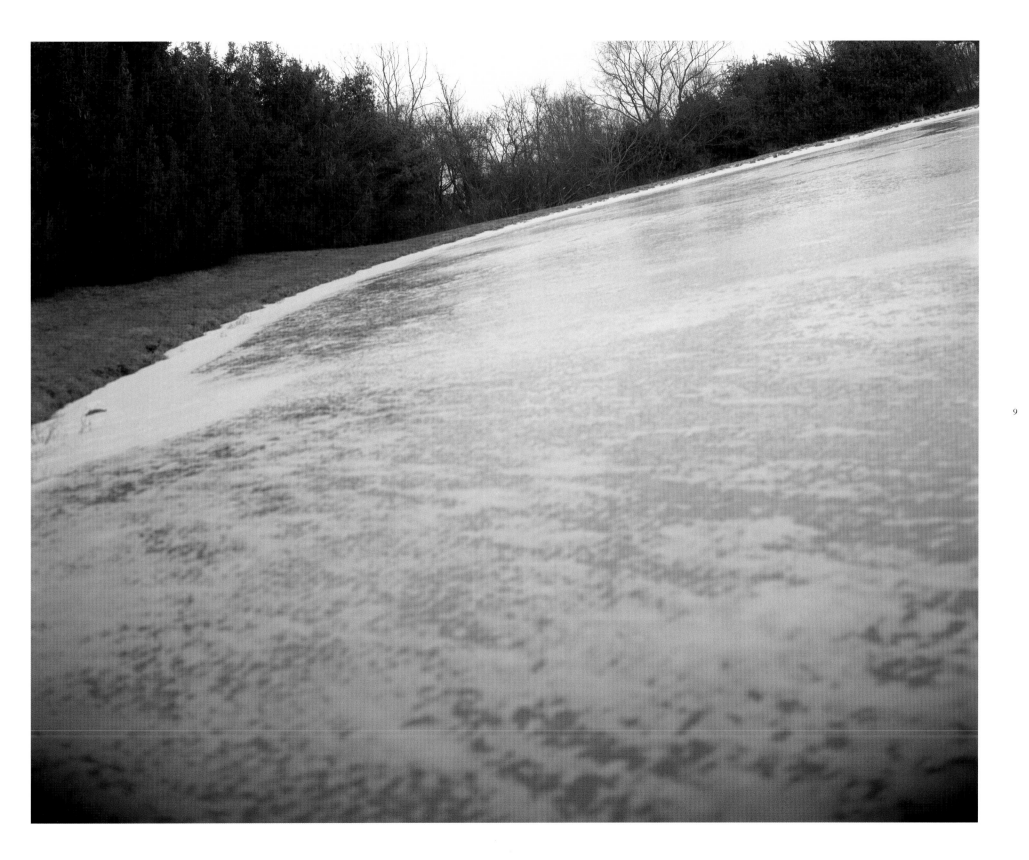

10

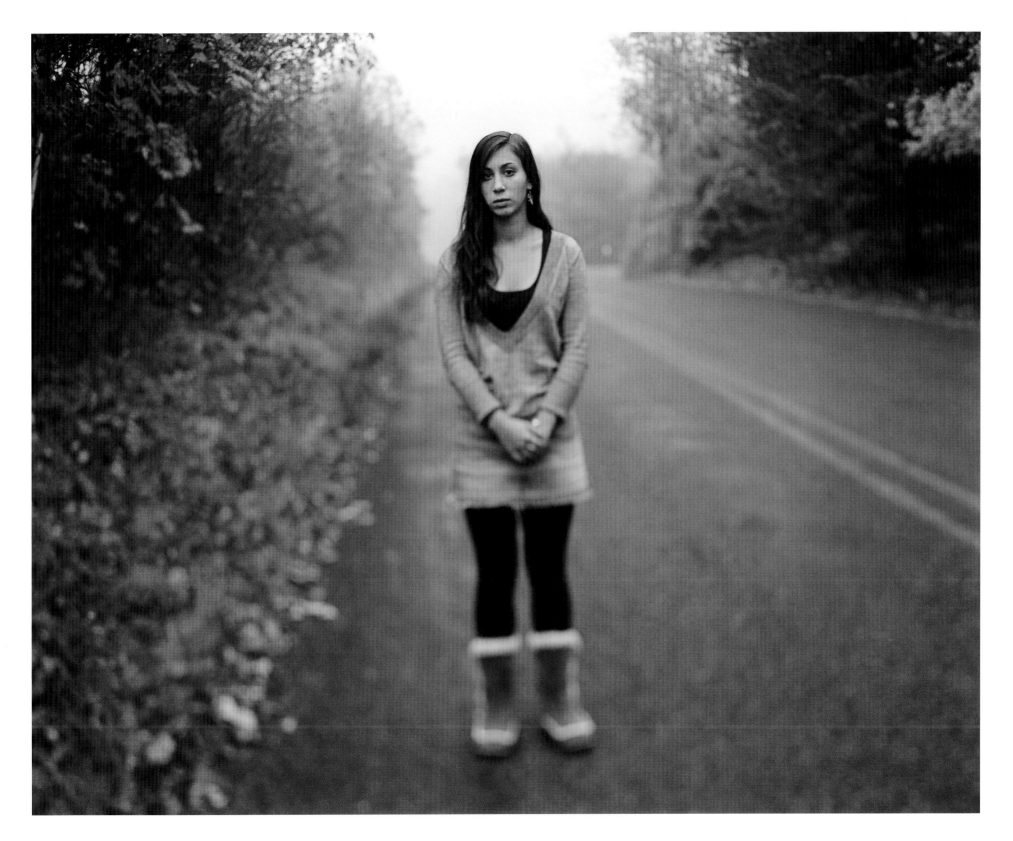

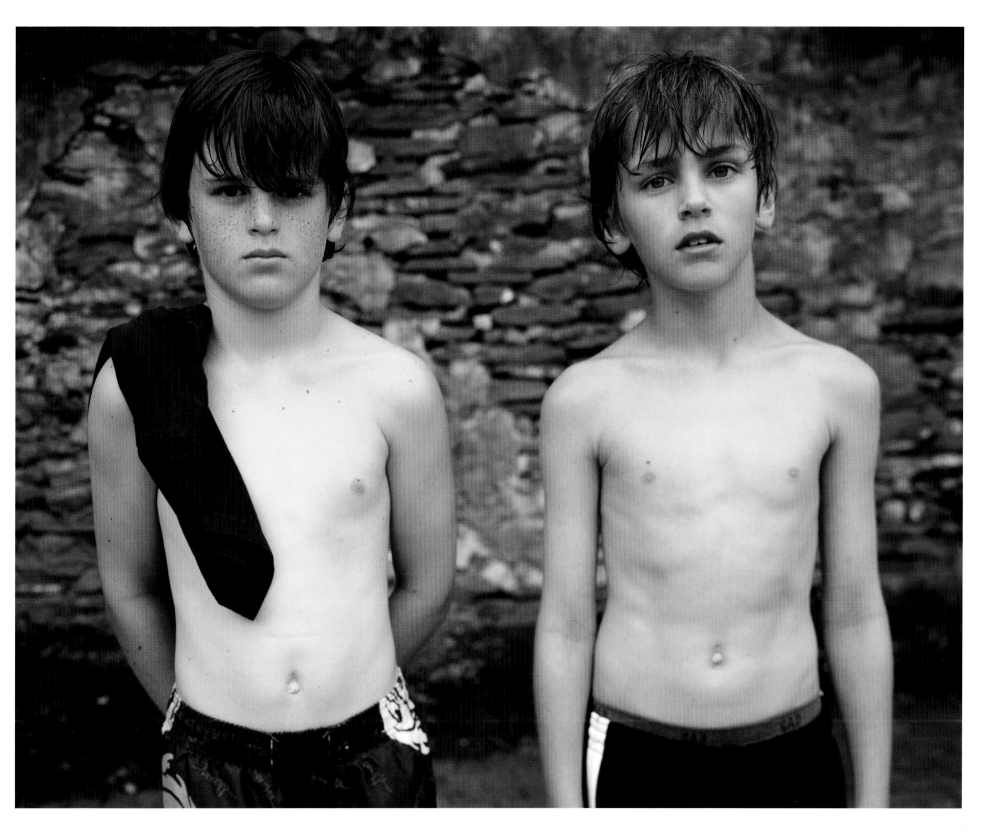

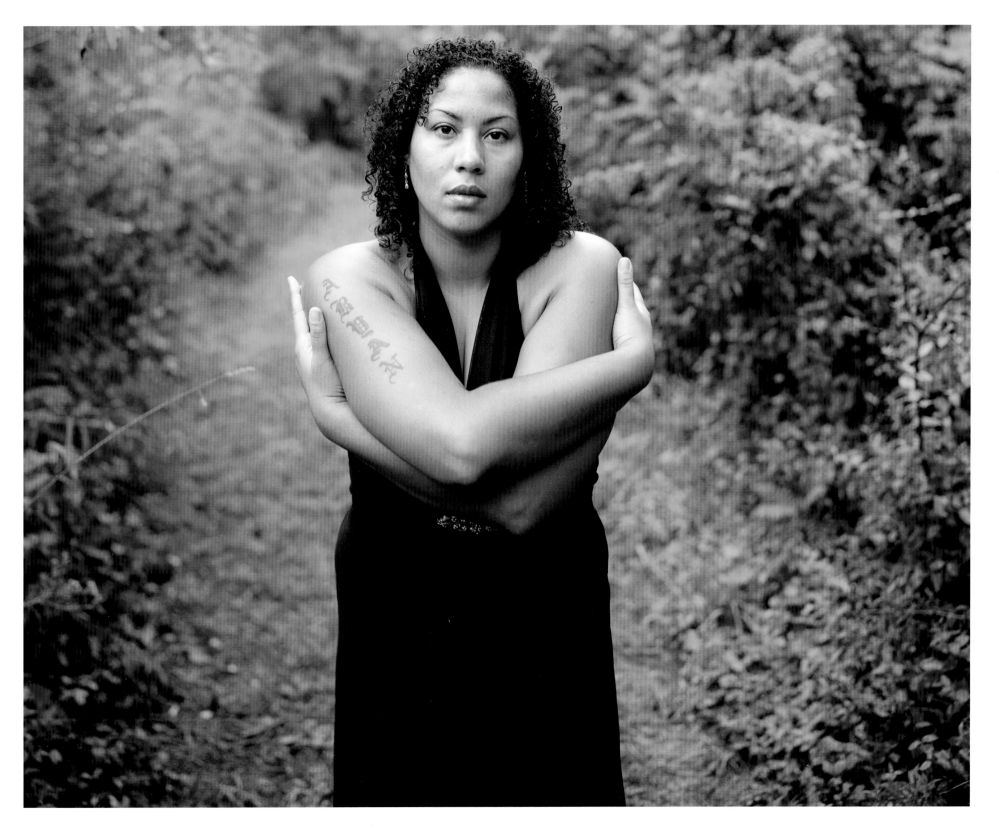

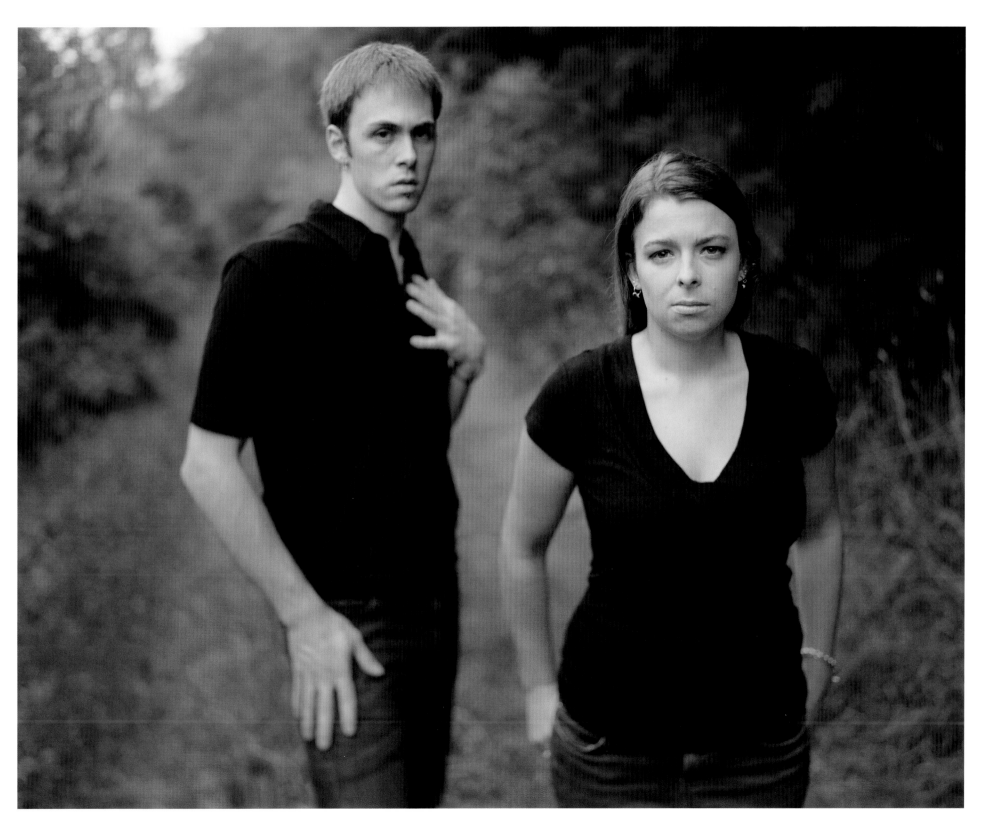

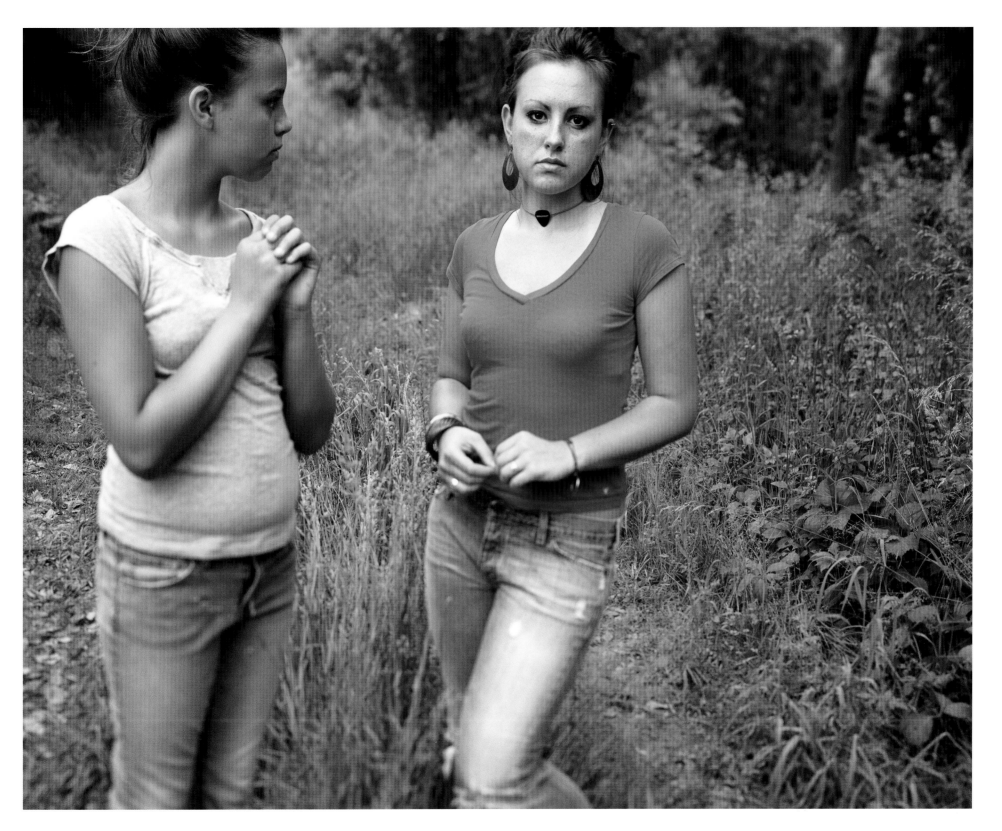

24

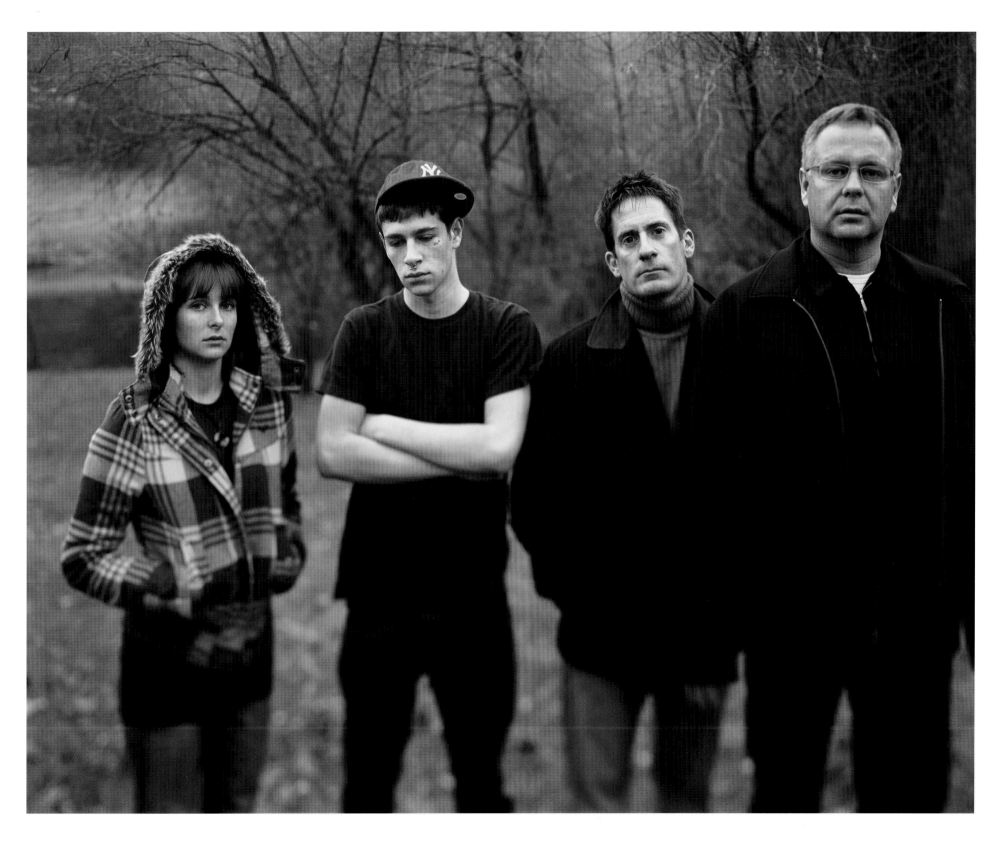

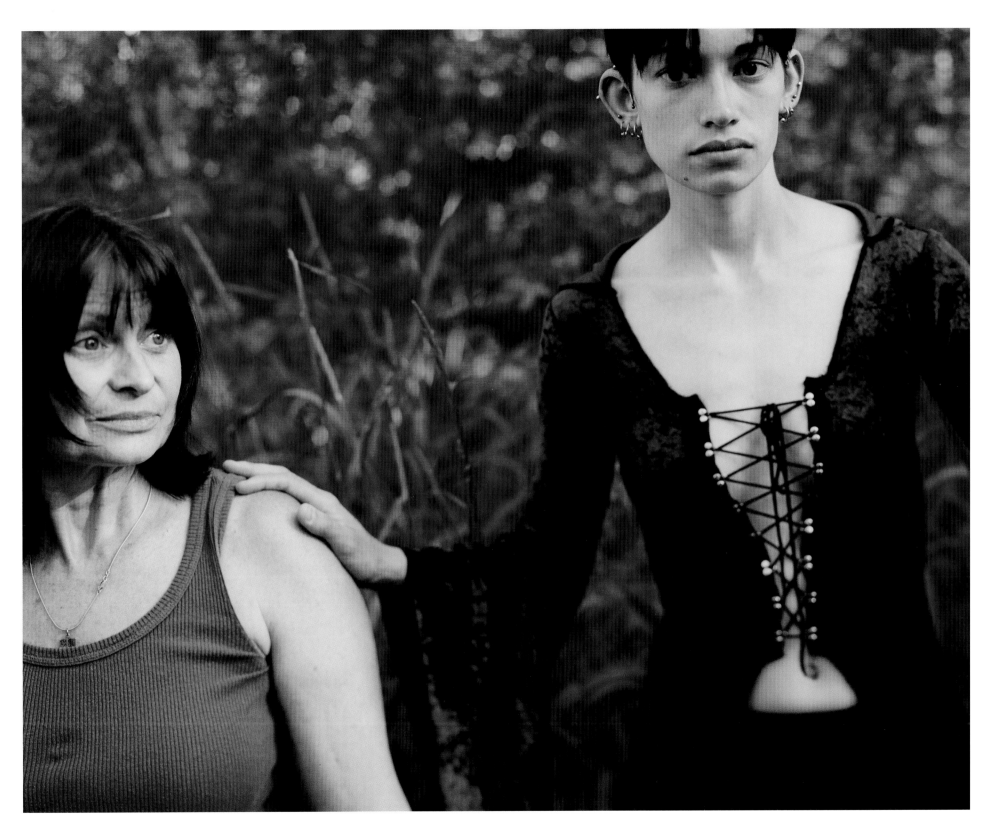

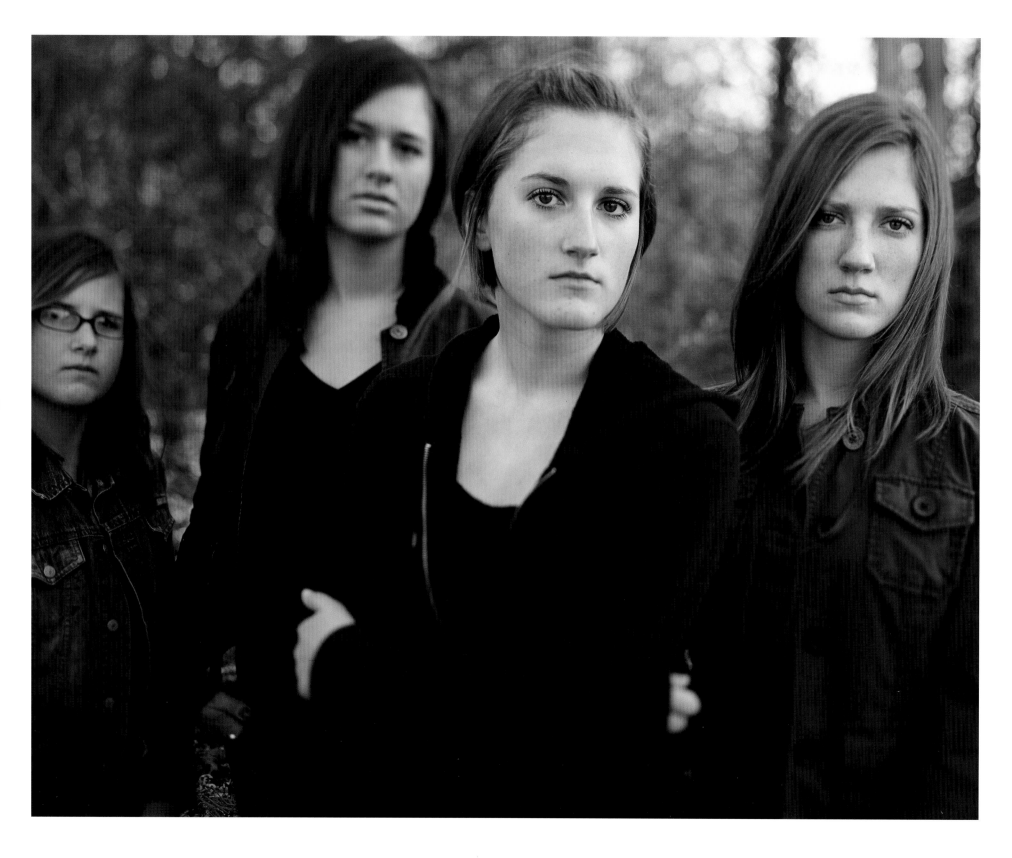

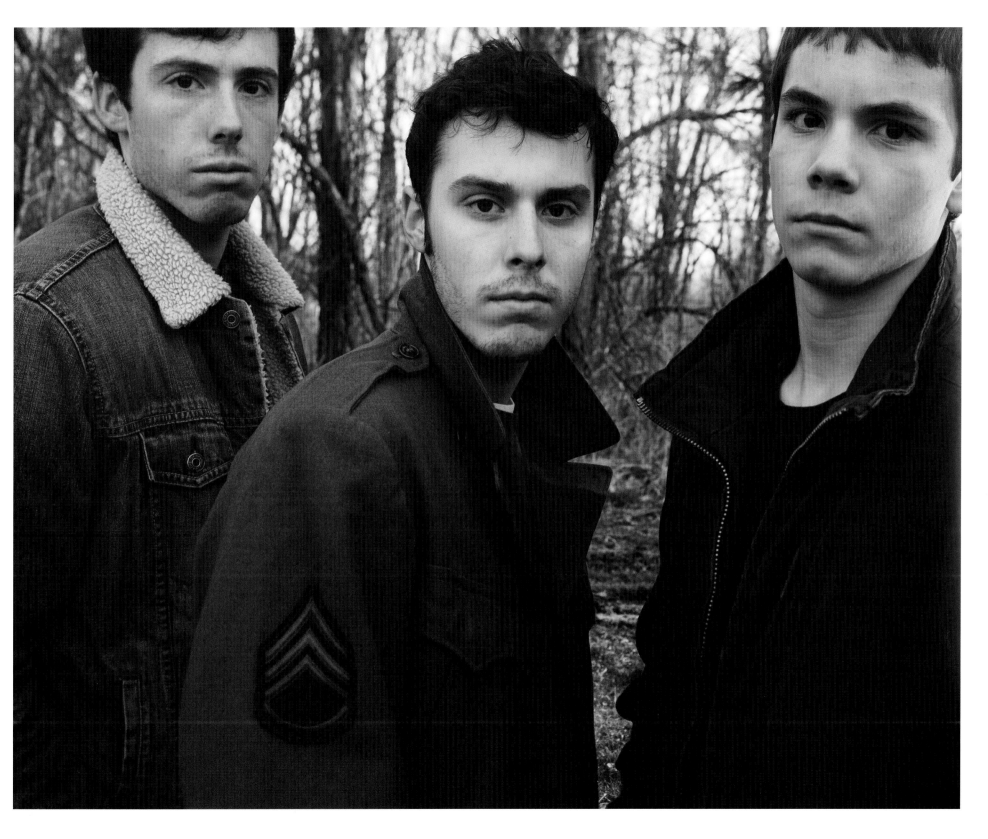

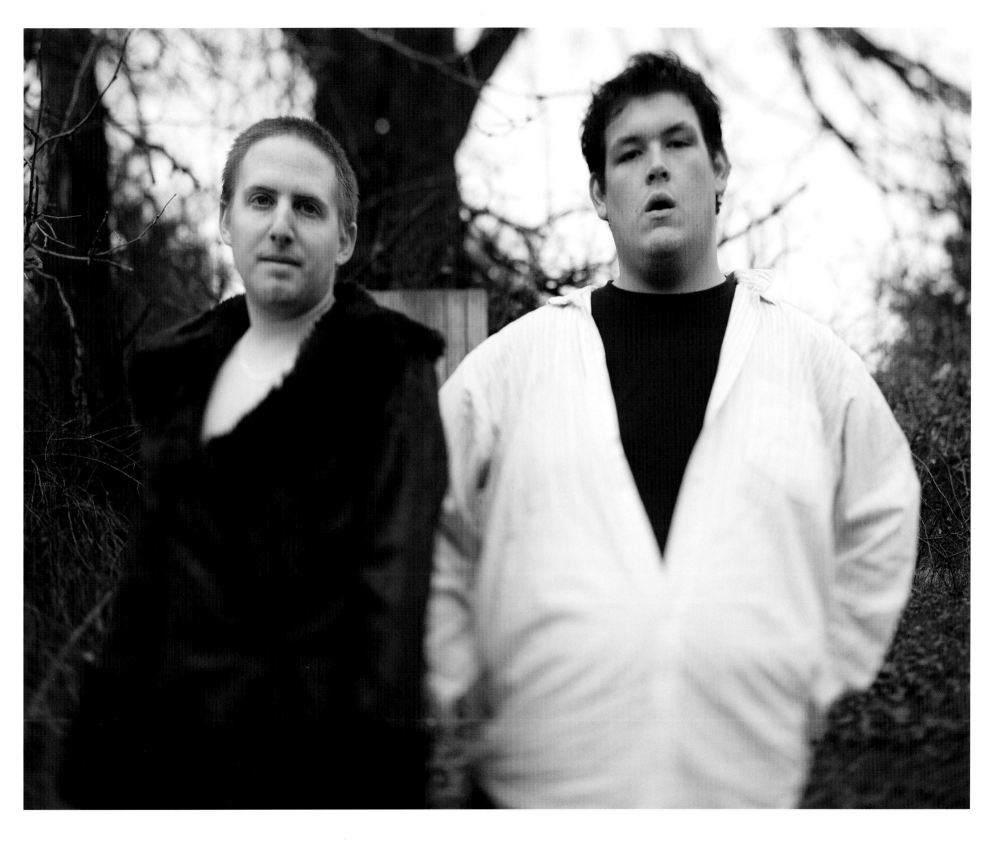

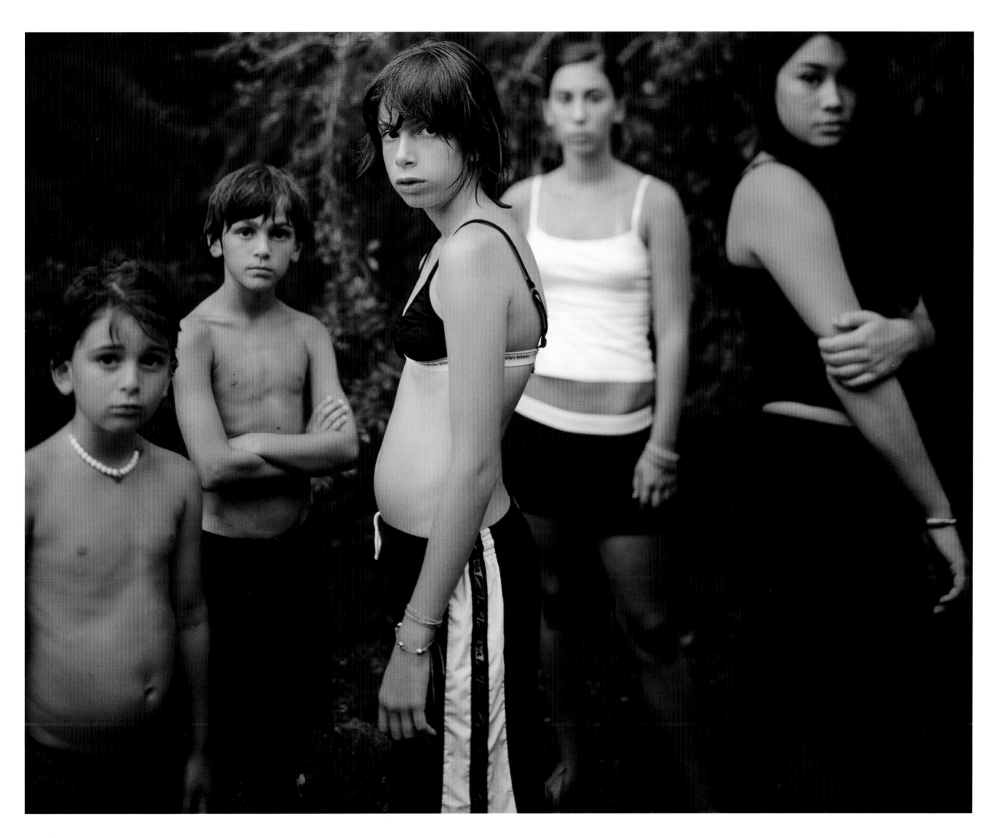

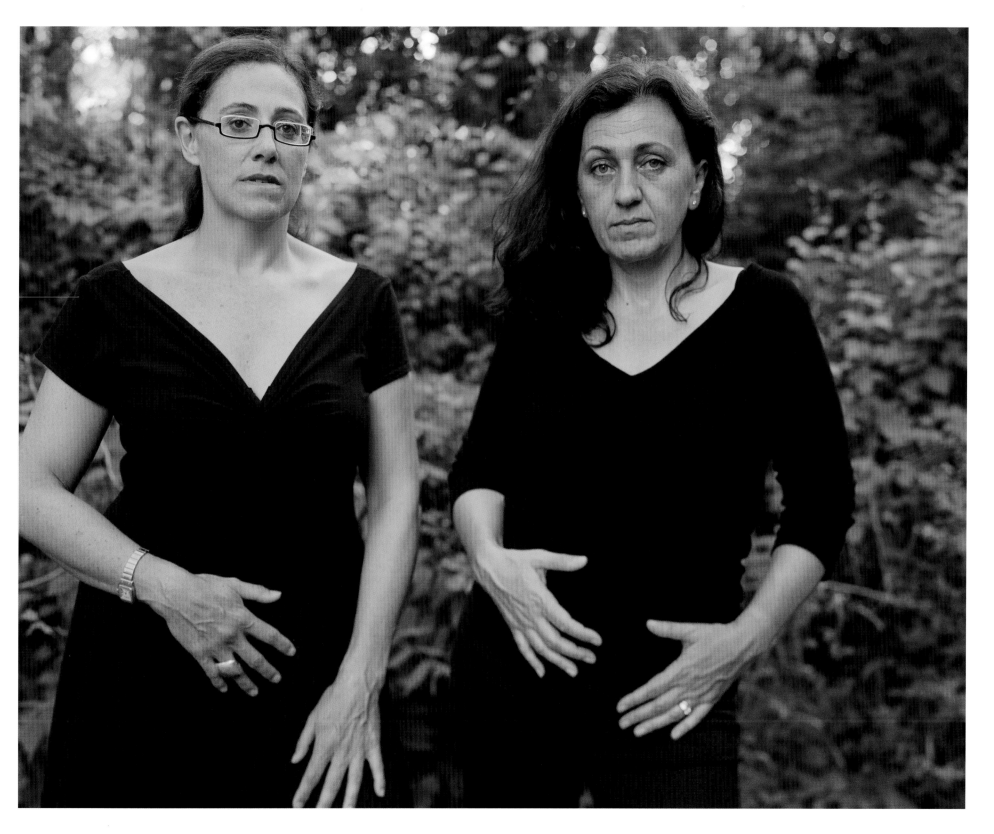

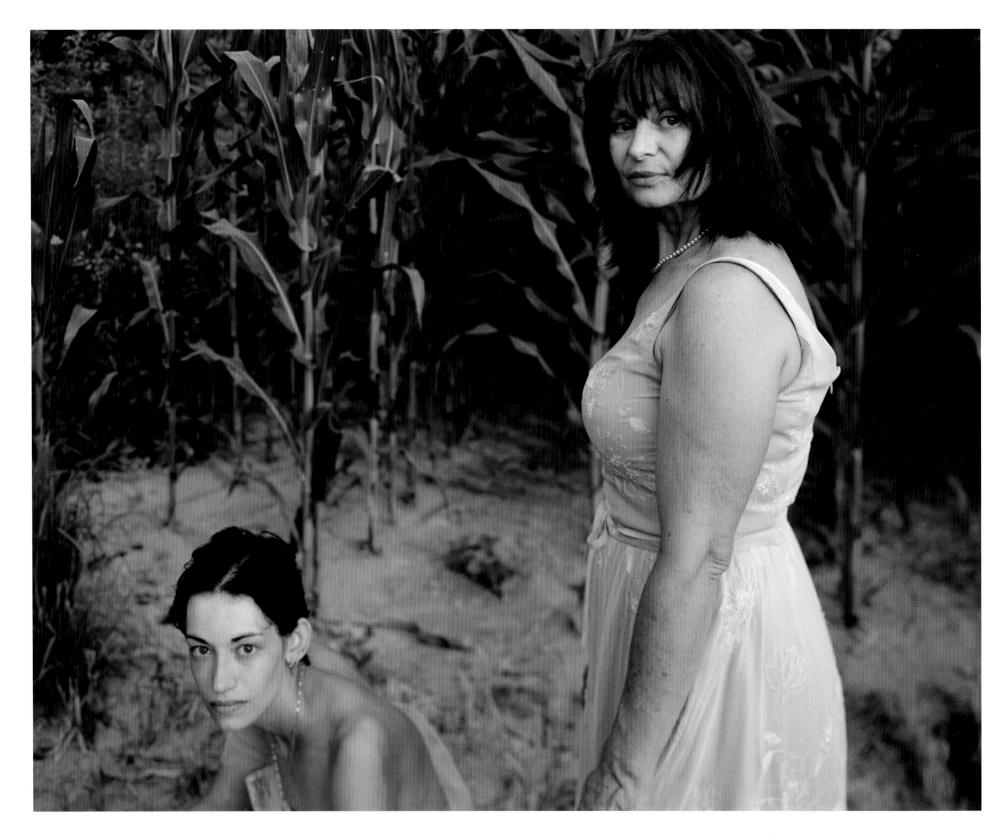

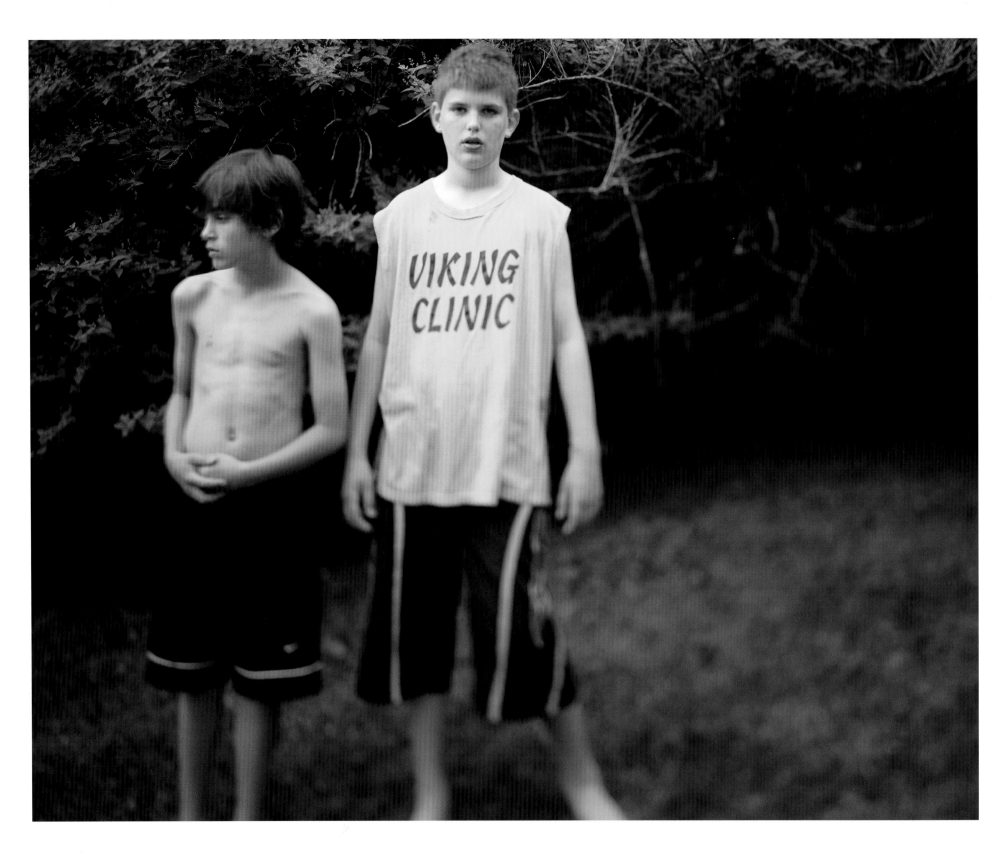

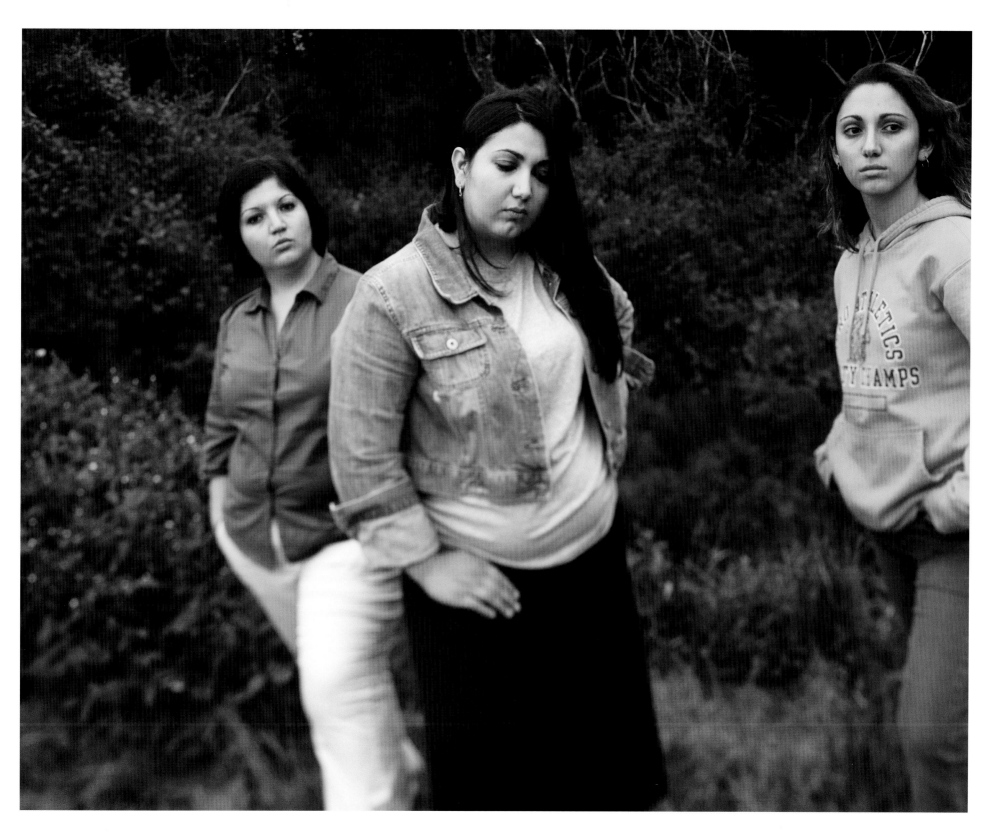

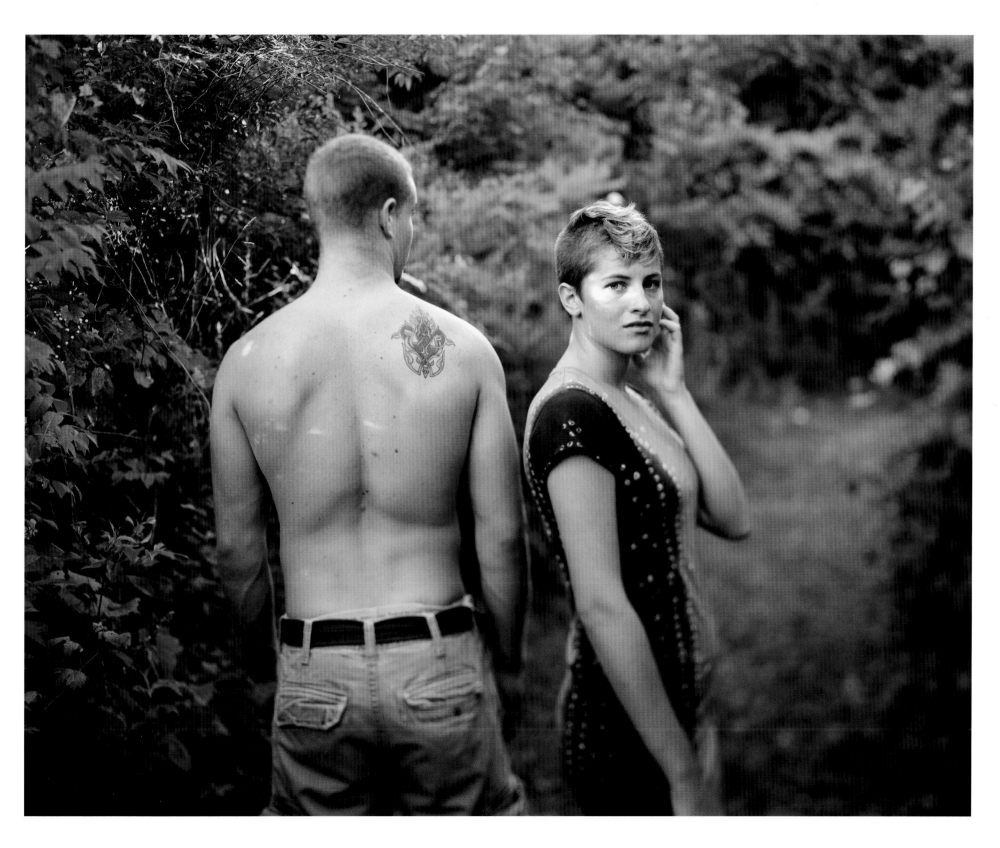

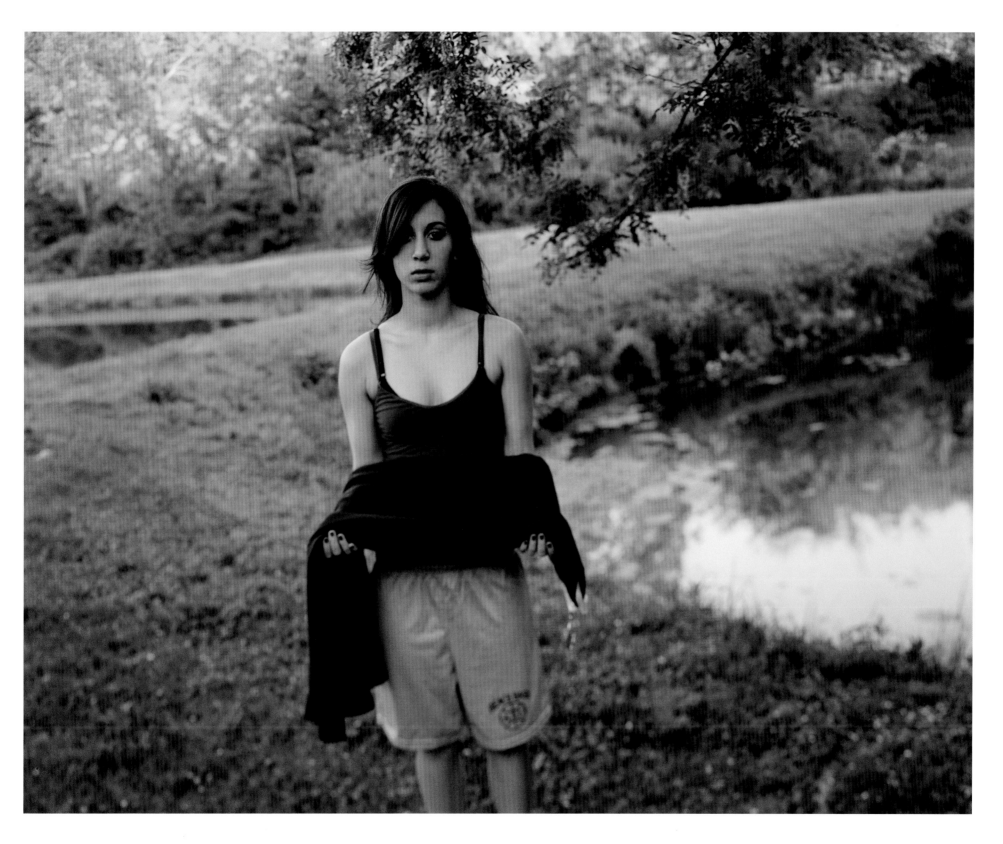

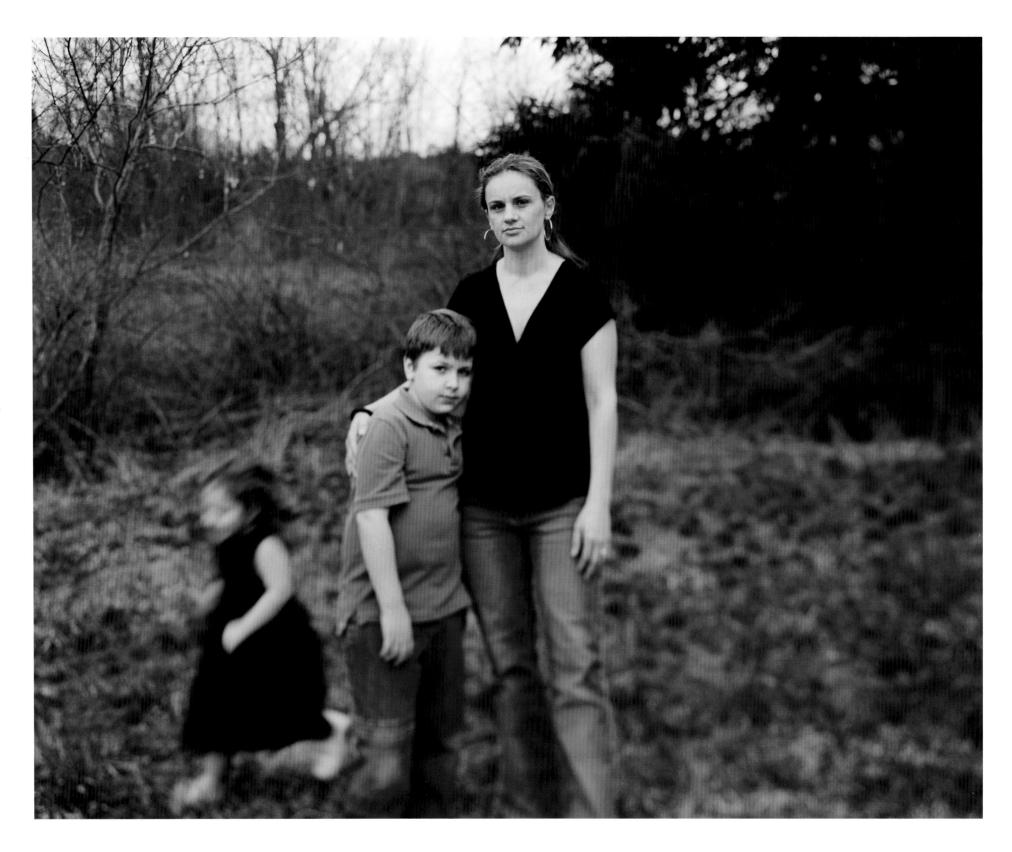

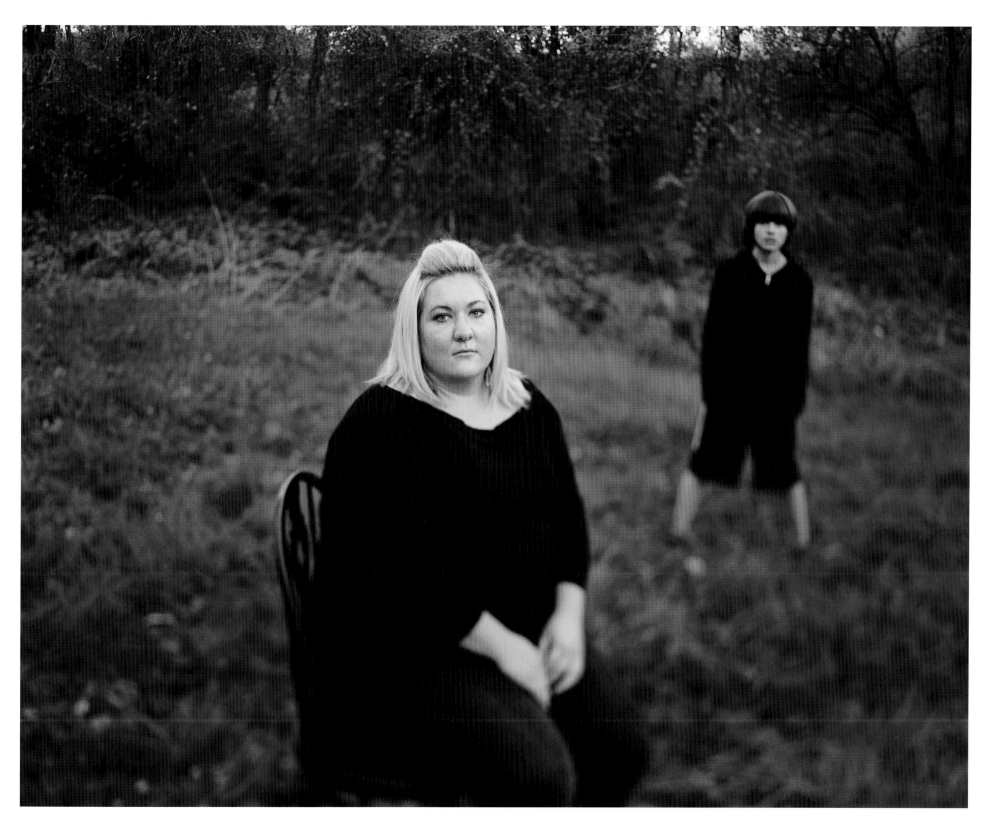
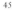

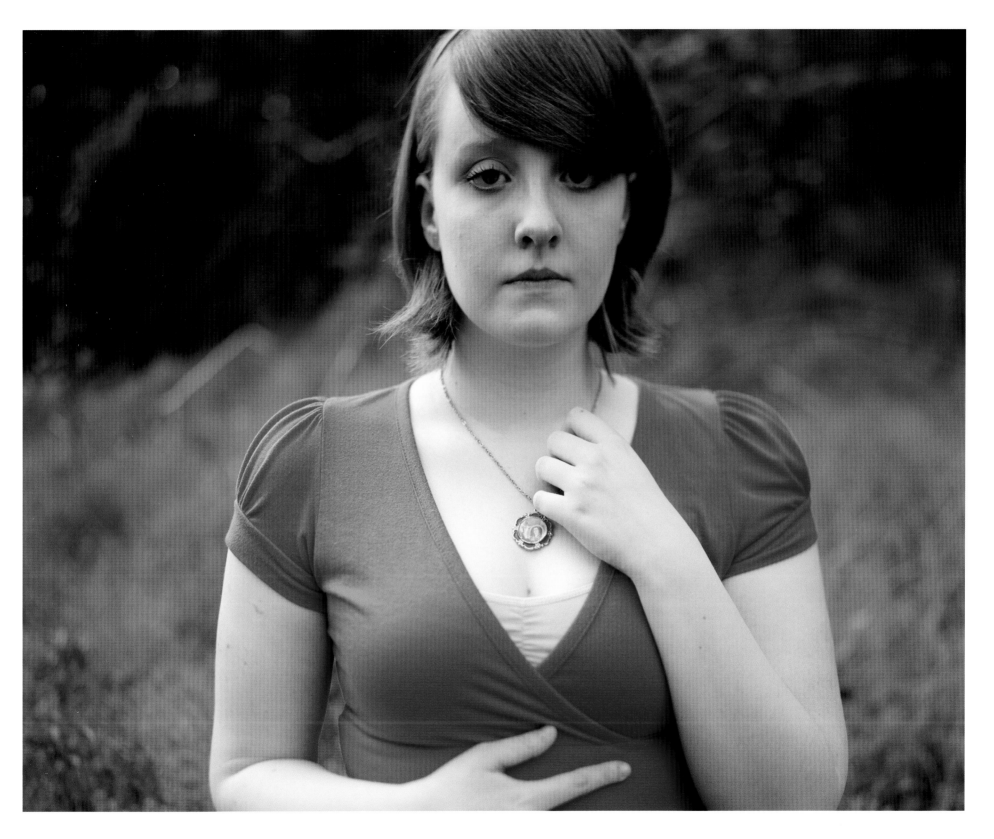

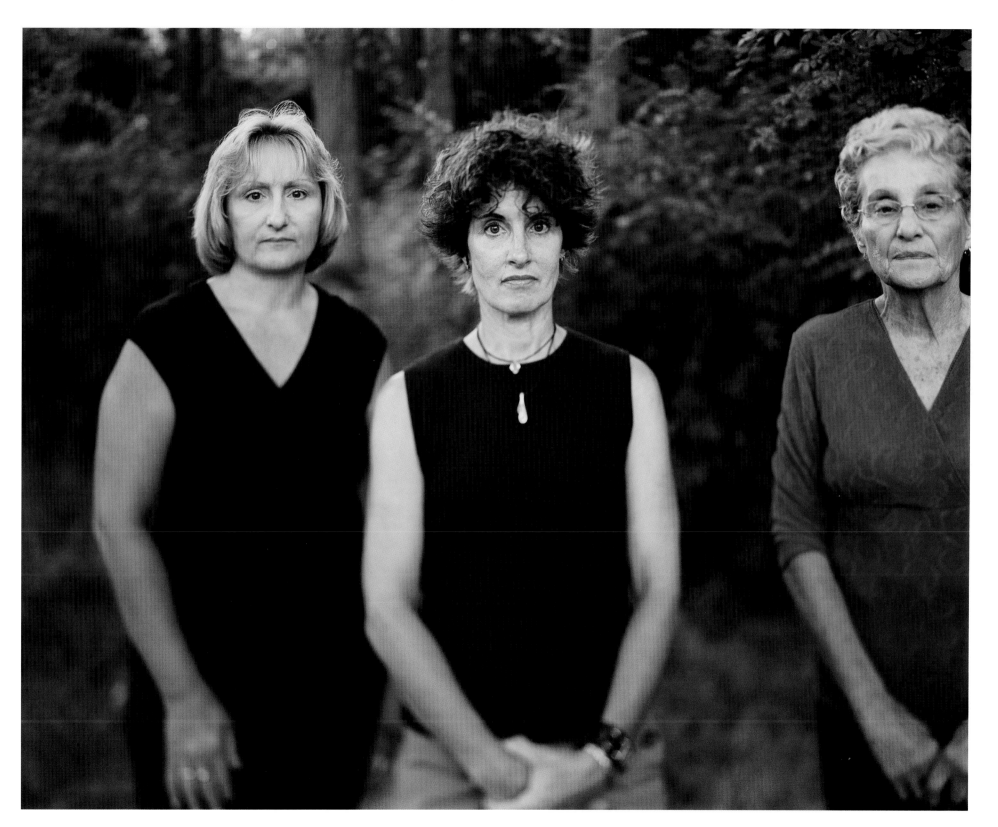
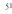

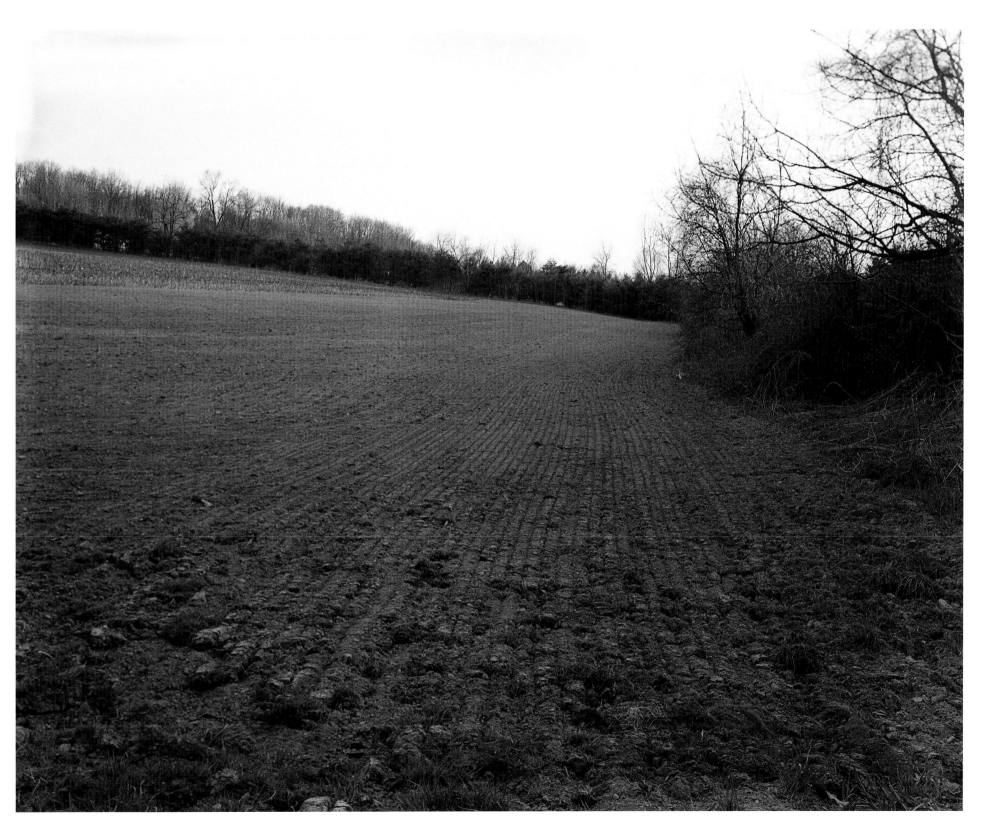

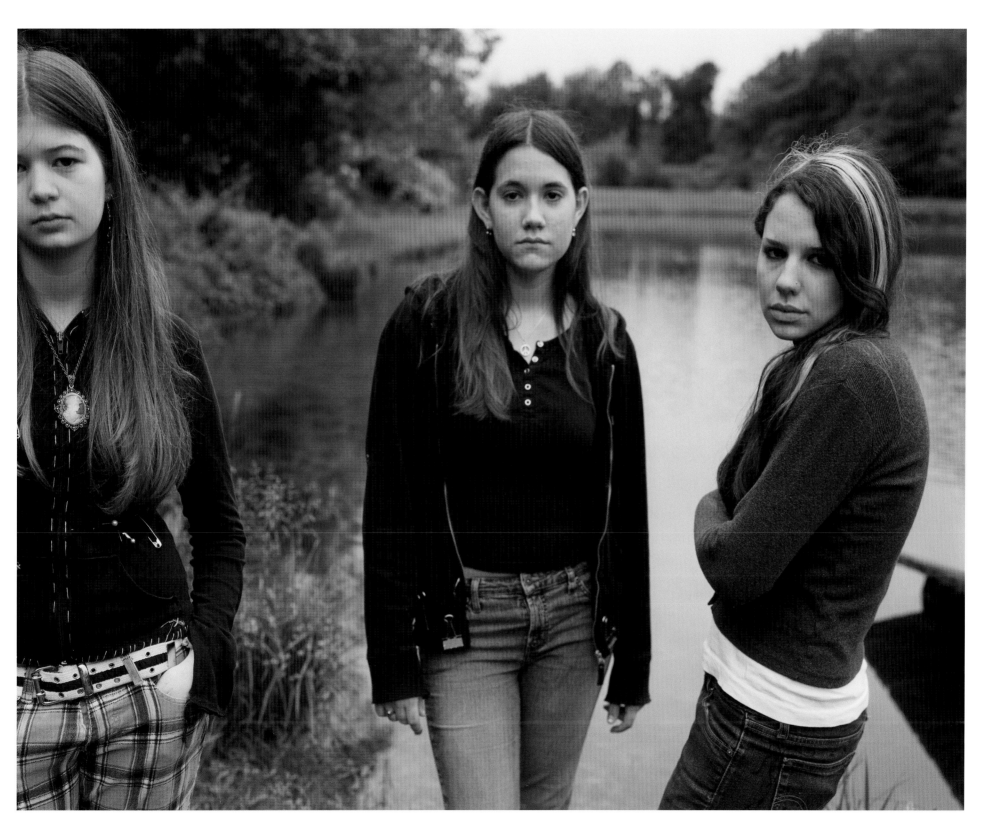

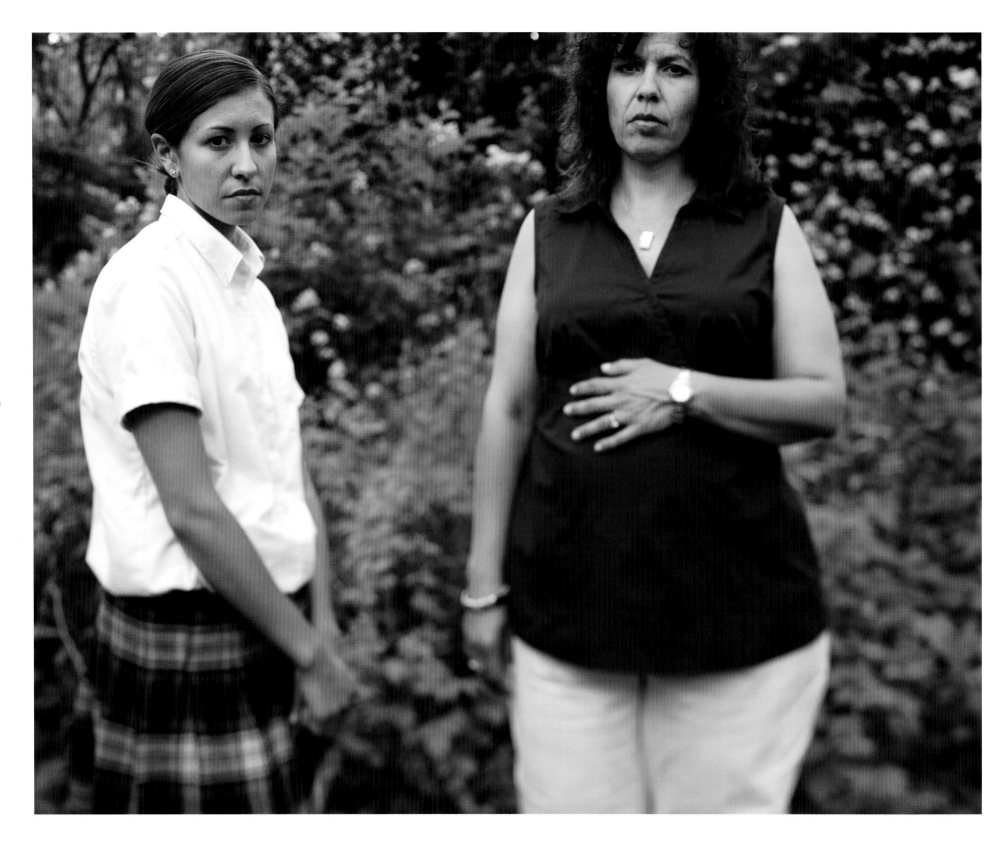

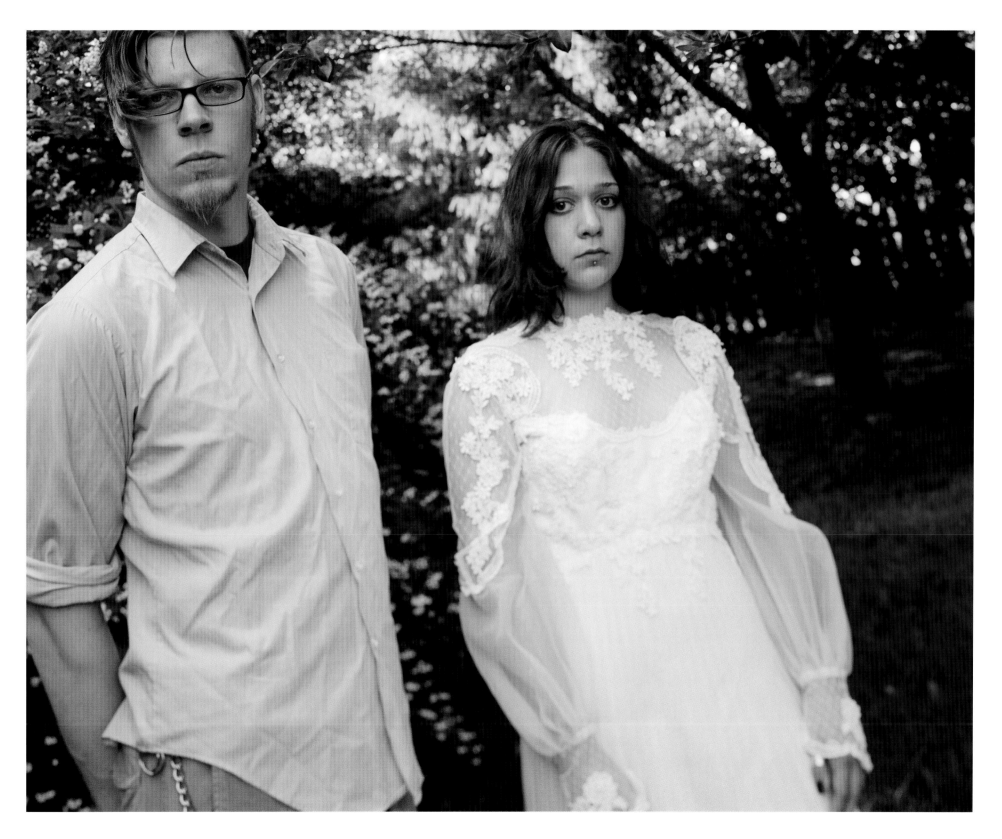

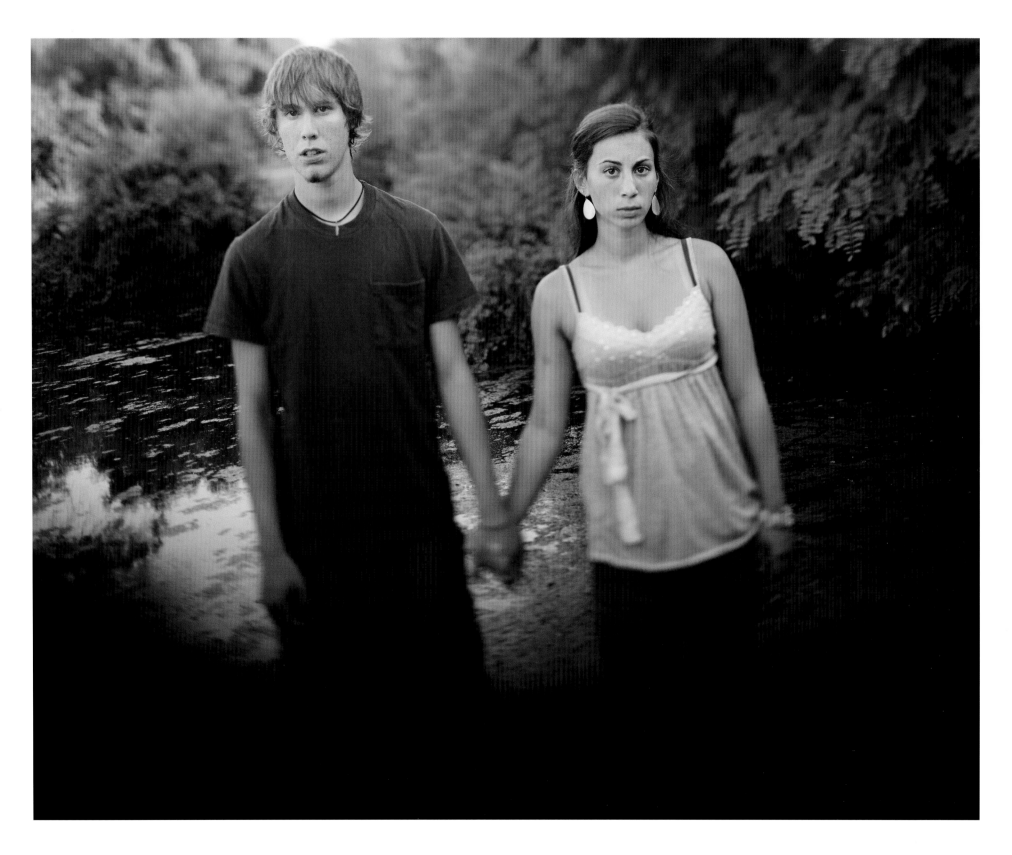

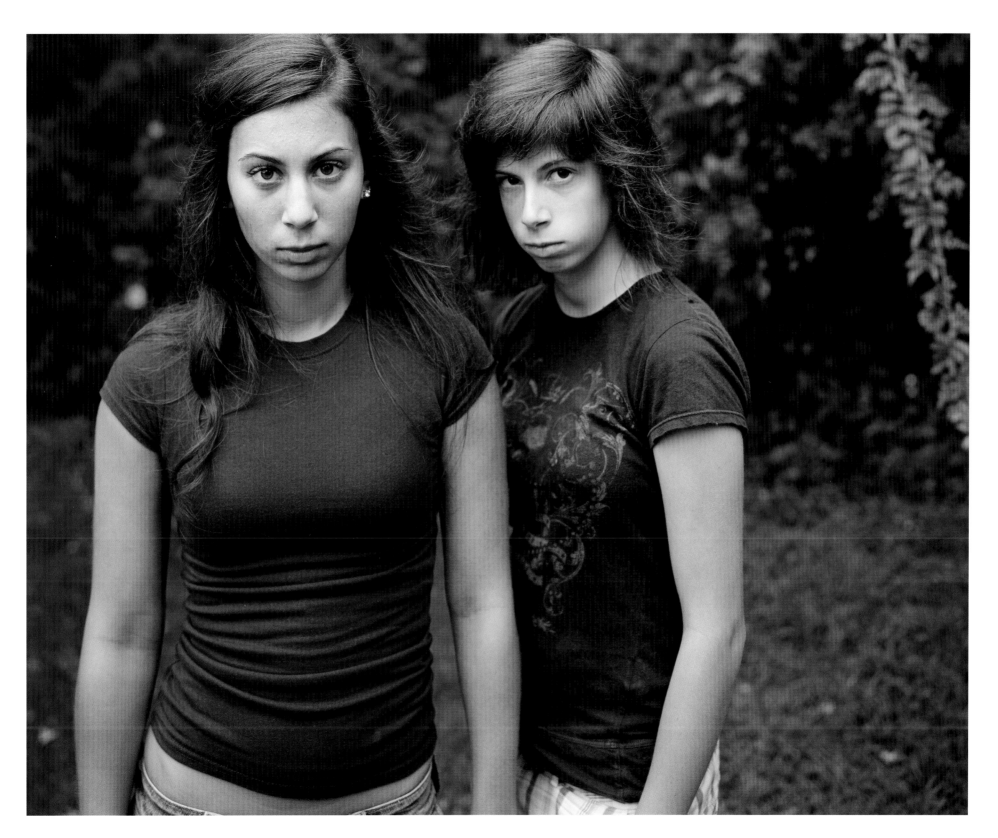

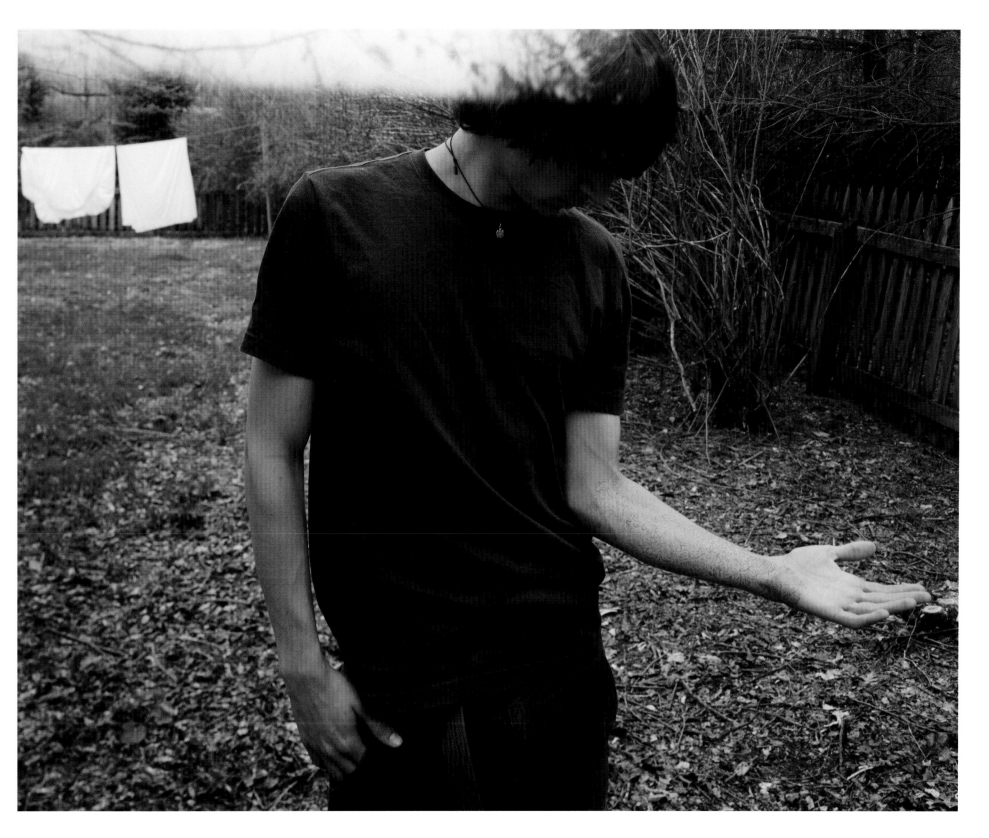

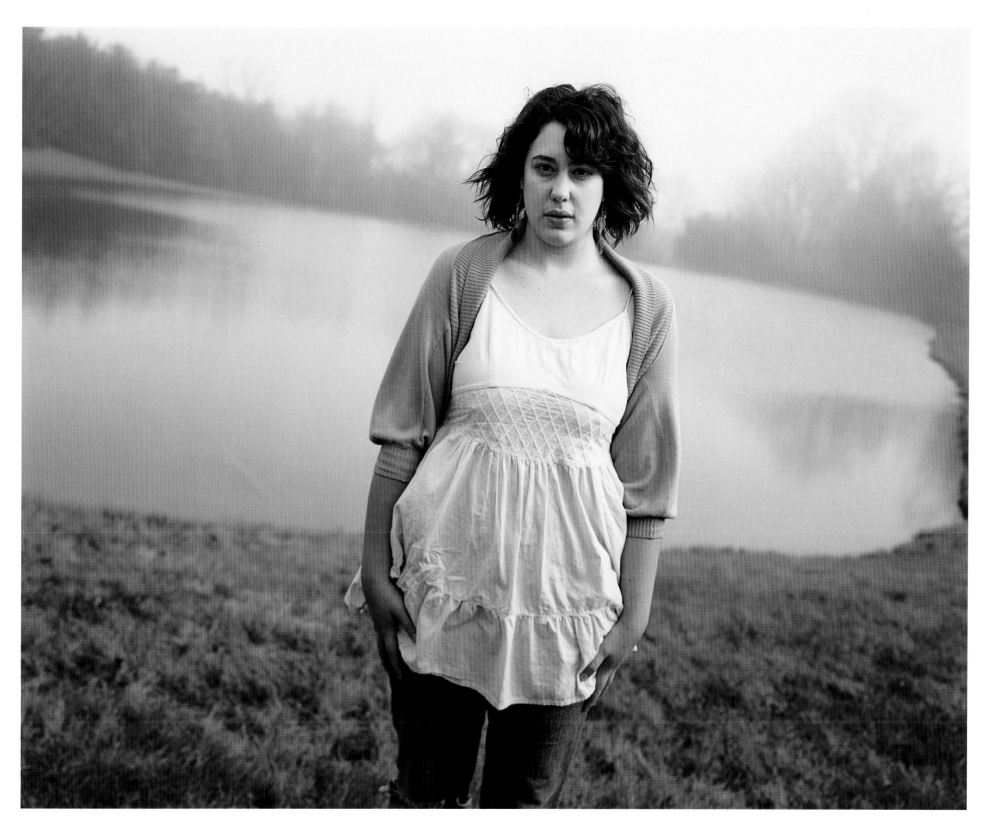

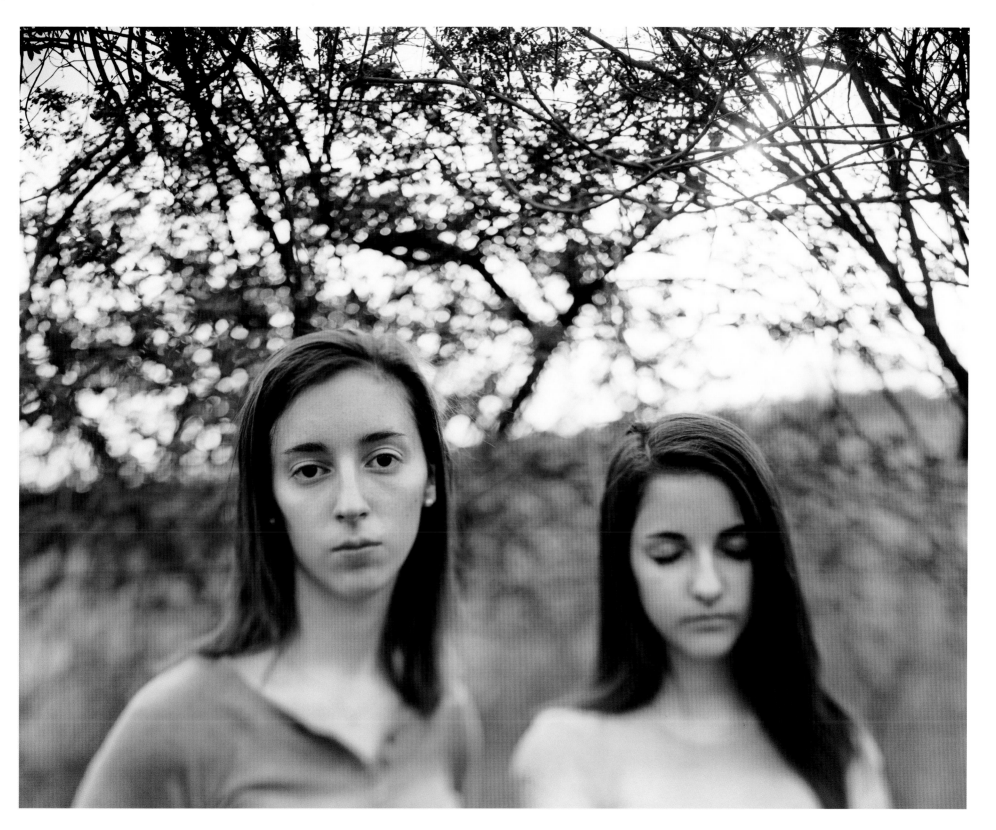

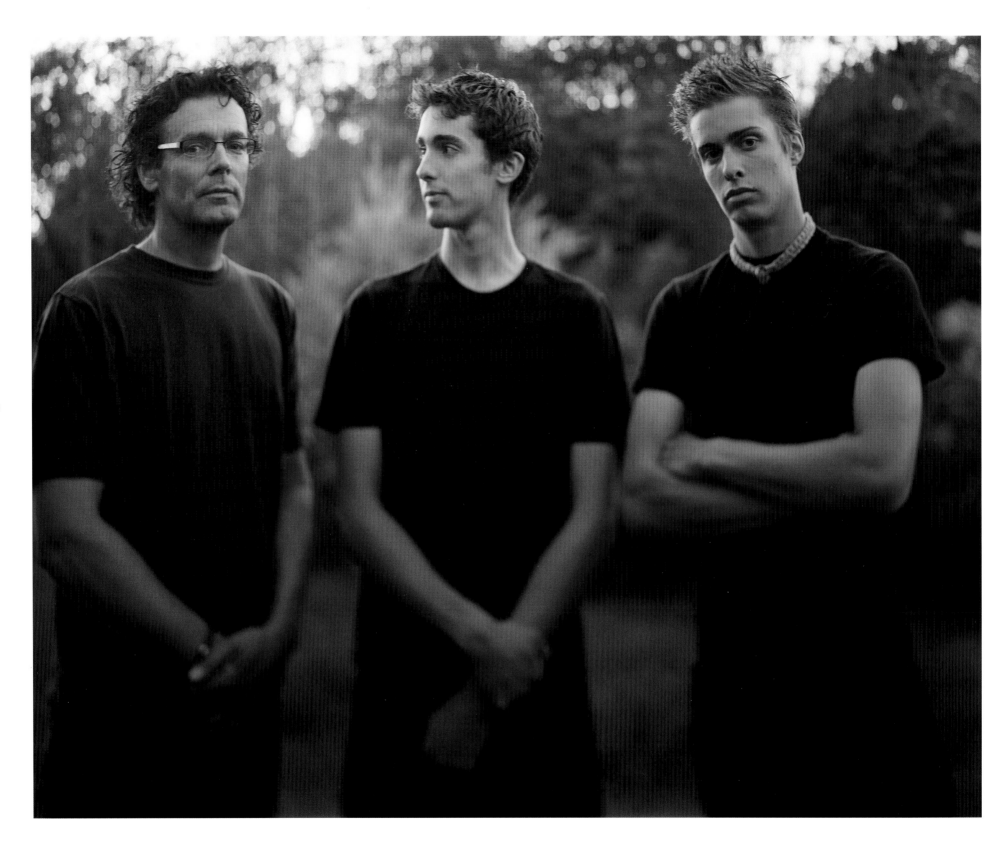

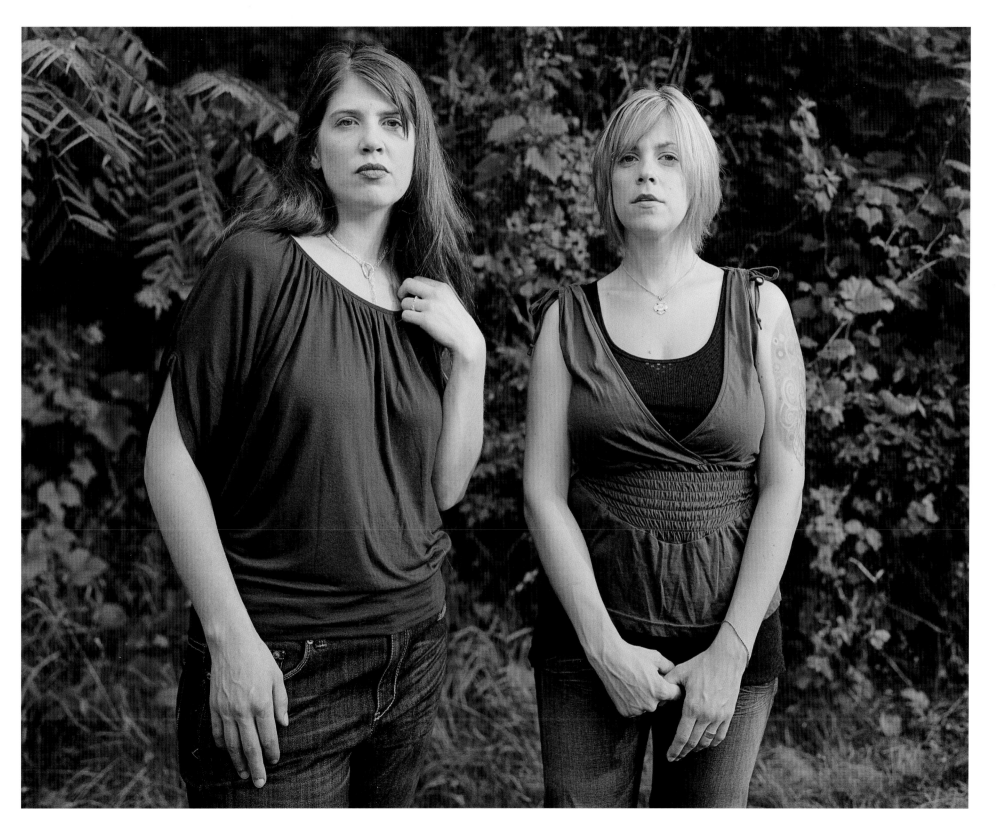

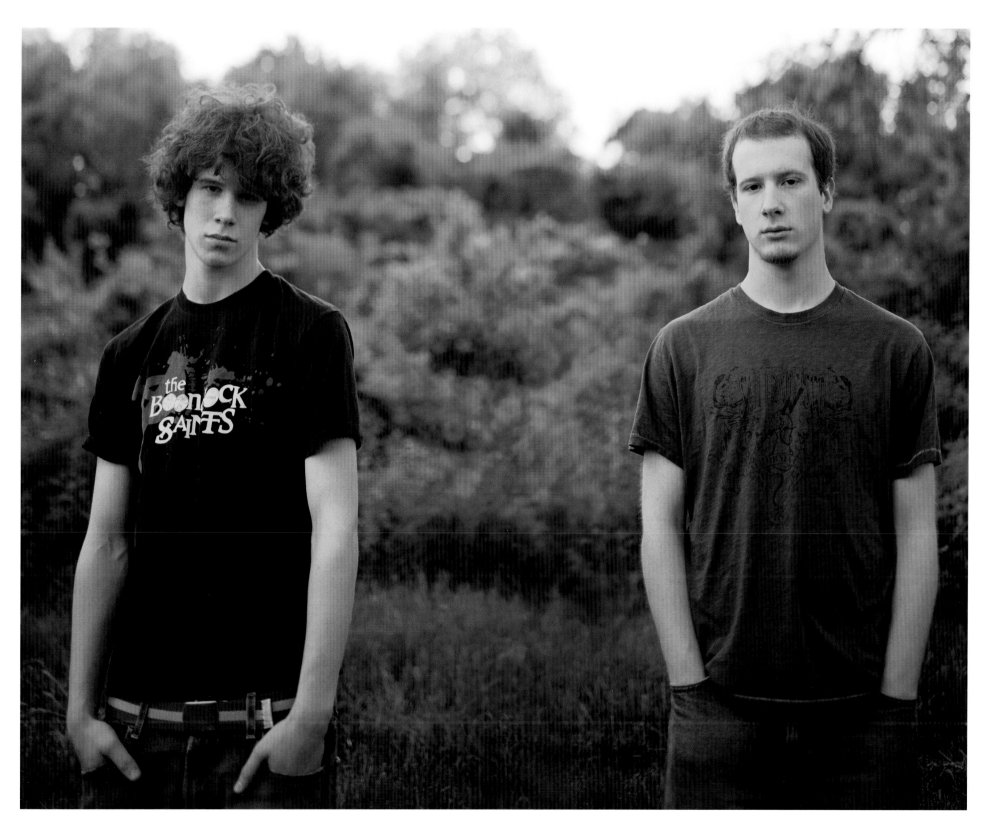

78

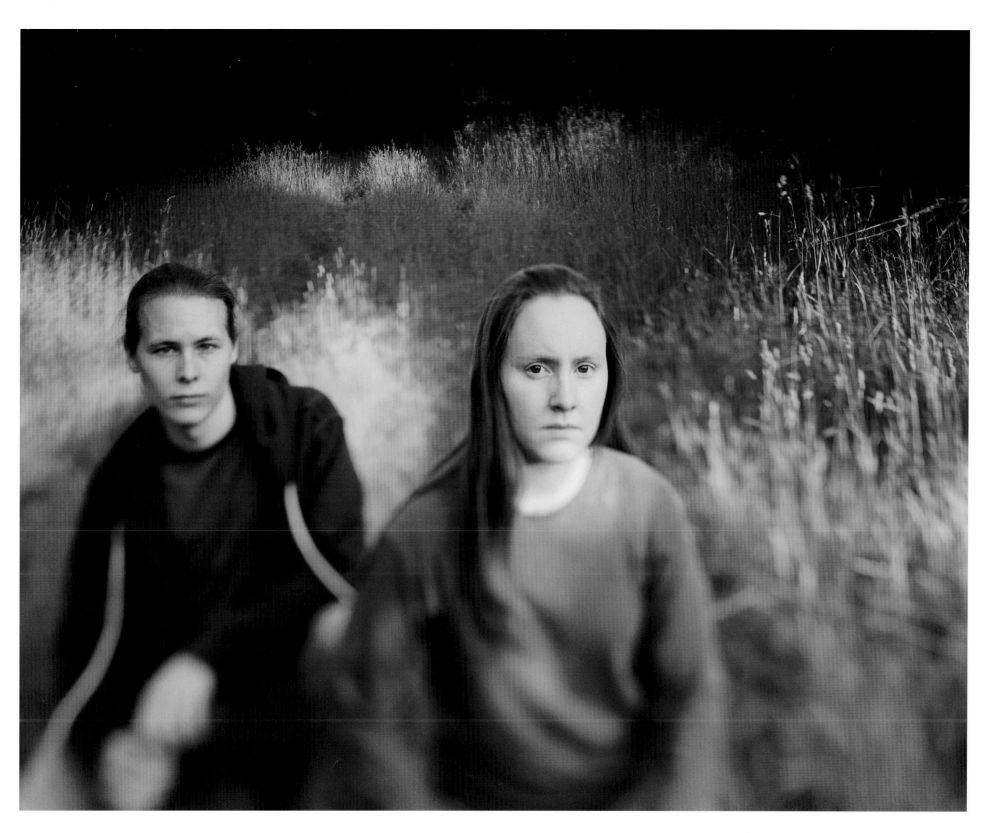

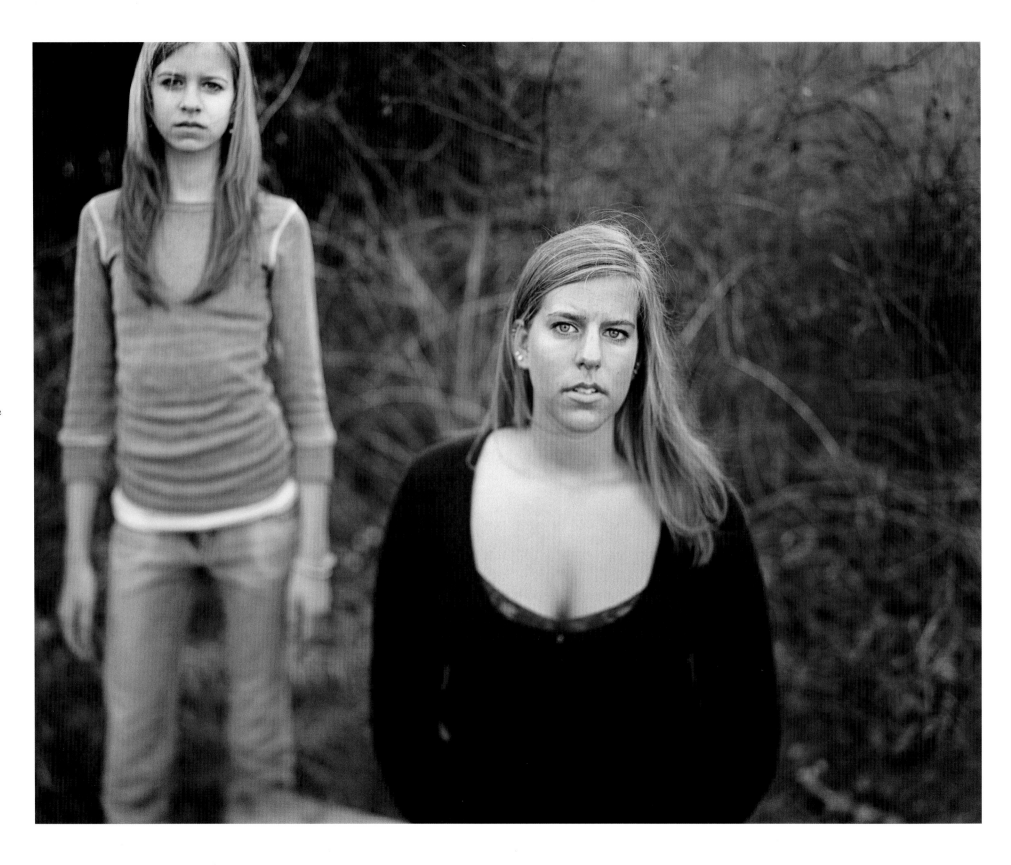

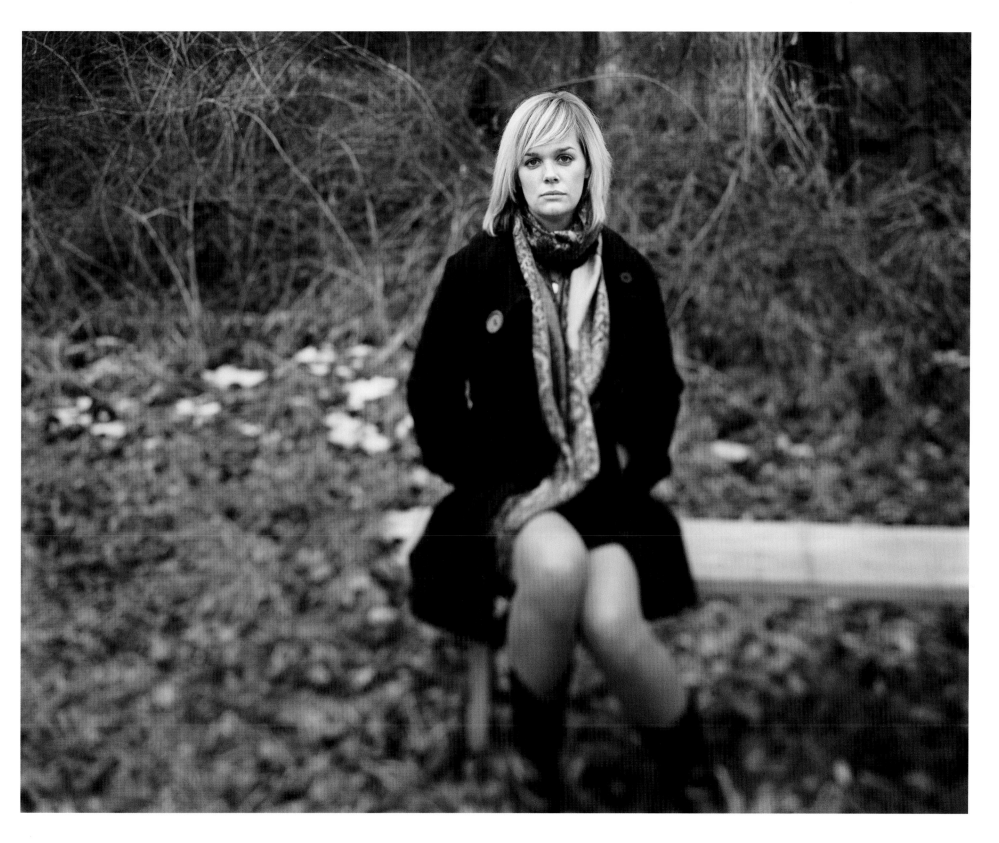

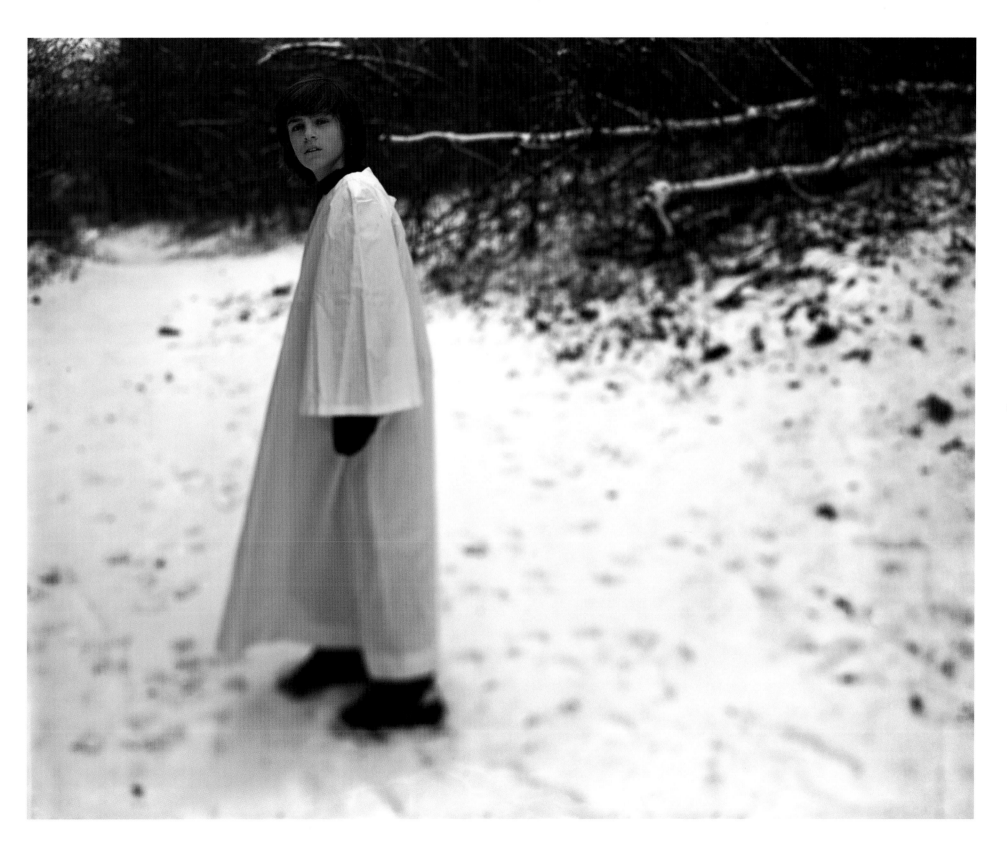

STATE OF NATURE
Encountering Lydia Panas Deeper in the Woods

One of this medium's naïve yet enduring tropes is that the photograph steals souls. That somehow, in the process of securing an image on film or pixels, the lens collects a bit of psychic patina, aural projection, or whatever you believe physically constitutes the soul. Most of us, today, would agree that this is unlikely. Our souls seem relatively safe from photographers. Agnostics, atheists, and avid believers of all stripes are immune from the shutter-snapping tsunami. Unless we determine that society as a whole is increasingly "soul-less" and start searching for causes, photography might actually be implicated—who really knows how we lose our souls, outside of Faustian bargains with Beelzebub at the crossroads. It's probably a slow process—or is it a plague?

All of this meandering about souls seems justified in the company of Lydia Panas's photographs, which seem uncommonly laden with soul, more than their fair share. The striking thing about her work, however, is that she and her subjects seem to have turned the old trope on its head. Looking at these photographs may cause you to lose your soul. The mesmerizing gazes, frank self-presentation, and utter absorption in the photographic exchange propels Panas's standers (we can't accurately call them sitters, can we?) from within their contained frame and through the fourth wall of spectatorship into a discomfiting engagement within our space of viewing. Another impossibility, of course, but who hasn't felt the gaze of a portrait subject push through the photographic membrane and grab some part of us? (Think Steve McCurry's Afghan girl, photographed in Pakistan in 1984. Or any number of Richard Avedon's subjects, or Jerome Liebling's, or Dorothea Lange's. Looks that emotionally strike us even at a huge remove of time and space.)

These are, then, empowered people, a condition Panas has bestowed upon them in the act of photographing. She has ennobled without hyperbole. None of these people are regal, and many seem profoundly

self-absorbed. Even in groups, the sense of individuality prevails. But every person is esteemed by Panas's photography, presented to us as the most exquisite visions of themselves. How does this happen? How does the common material of human form morph into these transfixing images?

One thing working in favor of the transformation from ordinary to extraordinary is the recontextualizing Panas carries out in her photographs, starting with her choice of locations. There is no apparent reason for these people to be in these spaces. This artifice is almost overwhelming. One image after another finds stylish, healthy, robust individuals dressed for school, weekends, or church (an altar boy in the snow!), out in the fields or wooded paths. Why? Whatever the answer, the fact is that the conceit works. We are faced with these figures, anomalously situated in spaces that suggest rural underpinnings but confirm nothing. Yet, the figures hold our interest. Hold, almost literally, as though the looks in their eyes cast out scaling hooks to secure our attention.

Is a directorial hand at work here? Instructions to the models, other than "compose yourselves" or "make yourselves comfortable"? There's a powerfully unnerving sense of observation coming back at us. Usually, photographs enable us to stare; they sanction the return gaze. But Panas's photographs are more permeable than most; the sense of presence nearly makes us avert our eyes. The frankness emanating from these friezes, these modern human clusters that define their own irrational spaces, is unsettling. Power, it seems, has been shifted; we viewers are at the mercy of the viewed, who (in their apparent, godlike omniscience) probably know more about us that we do about them. We clutch at straws of significance as we regard them. What are they wearing? Who are they? Are they related somehow? What can we glean of their realities that will somehow explain away the intensity of their eyes and the rationale for their grouping?

It was said of Alfred Stieglitz that he exercised some mesmeric power over his subjects. That, short of hypnotism, there could be no other explanation for why his photographs seemed to reveal invisible truths. To debunk this notion Stieglitz responded by photographing clouds, subject matter over which he could wield no power prior to the exposure. Panas probably hasn't hypnotized her subjects either,

but she seduces viewers into believing that unseeable things—life stories, emotions, even thoughts—are evident in her photographs. Is Panas's inclusion of unpopulated landscapes here a Stieglitz-like nod to the state of nature from which all life, story, and creative effort springs?

These photographs look easy. But while there is simplicity in Panas's project, it has the kind of motive force that sweeps waves of meaning and density with it. Like the best fairy tales, they happen in the woods and are loaded with aspects of myth and dream. As noted earlier, these images have an aura of frieze (or, "freeze," if you will) about them. They create a dwelling within the photographic frame, in that indeterminate space that is a photograph. It is a space of perception and intuition. It is a space that, instead of affording us the comfort of distance, draws us in to questions of presence—a personal space that enmeshes us in gaze. Having had these encounters, can we say we have learned anything? The lessons may be inchoate, hidden from view, but the experience of meeting Lydia Panas's photographs is nonetheless vivid.

George Slade

Our earliest relationships factor considerably in determining whom we turn out to be.

For three years, in hot and cold weather, I invited families of various forms to stand before my lens. I asked them not because I knew what to expect, but because I was curious to see what would happen. These groups and occasional individuals stood graciously before me. I watched how they arranged themselves and then began to photograph them with my view camera.

In these pictures of family relationships, the details matter most. Although they portray engaging people, verdant landscapes and beautiful light, the photographs also provide more subtle clues for understanding the nature of my work.

These images depict specific people, but they go beyond portraits to explore universal questions of how we see ourselves and what we feel. The pictures ask that we look deeper than the surface for what lies underneath: that complex part of our own personalities we often don't see.

Lydia Panas

94

LYDIA PANAS is an award-winning fine-art photographer whose works have been exhibited internationally. Her work is held in many public and private collections including the Brooklyn Museum, the Museum of Fine Arts Houston, the Museum of Contemporary Photography in Chicago, and the Shanghai Zendai Museum of Modern Art. Lydia's work has also been published internationally in publications such as the *New York Times Magazine*, *Photo District News*, the German edition of *GEO*, and *fotoMAGAZIN*, among others. Panas has degrees from Boston College and the School of Visual Arts, New York University/International Center of Photography. She has also received a Whitney Museum Independent Study Fellowship.

MAILE MELOY is the author of the story collections *Half in Love* and *Both Ways Is the Only Way I Want It*, which was named one of the Ten Best Books of 2009 by *The New York Times Book Review* and a best book of the year by *The Los Angeles Times* and Amazon. She is also the author of the novels *Liars and Saints* and *A Family Daughter*, and of a novel for young readers, *The Apothecary*. Meloy's stories have been published in *The New Yorker*, *The Paris Review*, and *Granta*, among other publications. She has received *The Paris Review's* Aga Khan Prize for Fiction, the PEN/Malamud Award, the Rosenthal Family Foundation Award from the American Academy of Arts and Letters, a California Book Award, and a Guggenheim Fellowship. In 2007, she was chosen as one of *Granta's* 21 Best Young American Novelists. She lives in Los Angeles.

GEORGE SLADE is a writer, historian, and curator of photography based in Minnesota. His essays and reviews appear extensively online, (including on his own web site, re:photographica) and in print. He received a 2007 Warhol Foundation Creative Capital Arts Writers Grant Program award for his ongoing project, *Looking Homeward*, linking memory, history, and archival photographs.

© 2011 Kehrer Verlag Heidelberg Berlin,
Lydia Panas and authors
Texts: Maile Meloy, George Slade
Proofreading: Wendy Brouwer
Image processing: Kehrer Design (J. Hofmann)
Production and design: Kehrer Design (T. Streicher, K. Stumpf)

Bibliographic information published by
the Deutsche Nationalbibliothek:
The Deutsche Nationalbibliothek lists this publication
in the Deutsche Nationalbibliografie; detailed bibliographic
data is available on the Internet at http://dnb.d-nb.de.

ISBN 978-3-86828-229-0

 Kehrer Heidelberg Berlin
www.kehrerverlag.com